IMAGES
of America

SEATTLE
FIRE DEPARTMENT

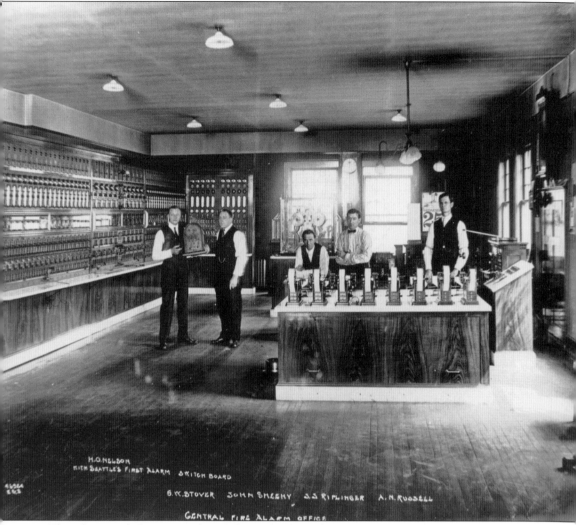

H.O.NELSON
WITH SEATTLE'S FIRST ALARM SWITCH BOARD

G.W.STOVER JOHN SHEEHY J.J.RIPLINGER A.H.RUSSELL

CENTRAL FIRE ALARM OFFICE

This photograph from around 1915 shows chief fire-alarm operator Joe Riplinger (in white shirt and bow tie) with some of his crew at Seattle's Central Fire Alarm Center on the third floor of the headquarters fire station at Third Avenue South and Main Street. The code number of a fire-alarm box pulled at any location in the city would be recorded in this office on one of the eight tape registers pictured. It would also be struck on a bell for its designated circuit. The fire alarm crew would retransmit that number by bell to all fire stations. By means of specific assignment cards for each fire-alarm box, the firefighters at the stations could determine the location of the fire box and which units were required to respond there. (Courtesy of LRFD.)

ON THE COVER: The fire department band was photographed around 1915 in front of the head-quarters fire station at Third Avenue South and Main Street with several of the newly acquired motor fire apparatus. In the lead is longtime assistant chief William Clark. Though never permanently appointed chief of the fire department, "Skipper" Clark served as the interim chief during several rocky periods in the department's history. (Courtesy of MOHAI, 83.10.10187.)

IMAGES
of America

SEATTLE
FIRE DEPARTMENT

Richard Schneider

ARCADIA
PUBLISHING

Published by Arcadia Publishing
Charleston SC, Chicago IL, Portsmouth NH, San Francisco CA

Printed in the United States of America

Library of Congress Catalog Card Number: 2006931267

For all general information contact Arcadia Publishing at:
Telephone 843-853-2070
Fax 843-853-0044
E-mail sales@arcadiapublishing.com
For customer service and orders:
Toll-Free 1-888-313-2665

Visit us on the Internet at www.arcadiapublishing.com

*To all who have served the City of Seattle through its fire department,
especially those who made the ultimate sacrifice.*

CONTENTS

ACKNOWLEDGMENTS

The list of those who deserve credit for their assistance in assembling this book is almost too long to be printed. They include the people at Arcadia Publishing, especially Julie Albright, as well as Seattle fire chief Greg Dean and all the members of the fire department who devoted time and material to the project. Special thanks goes to those organizations and individuals who were the source of the photographs used. The sources named in this list are followed where appropriate by their abbreviation in parentheses. Because of space limitations, these abbreviations appear in the photograph credits. Thanks goes to Seattle Local 27, the International Association of Fire Fighters, with special thanks to administrative assistant Aaron Vanderslice (Local 27); the Seattle Museum of History and Industry, with special thanks to Carolyne Marr and Howard Giske (MOHAI); the University of Washington Special Collections Library, with special thanks to Nicolette Bromberg (UW); the collections of Boyd and Galen Thomaier and the Last Resort Fire Department (LRFD); the Seattle Fire Department's own collection (SFD); the Seattle City Archives, with special thanks to Jeff Ware; the collections of Jim Stevenson and Betty Stanton; the collection of the late chief William Fitzgerald; the collection of former chief Claude Harris; photographers, past and present, from the *Seattle Times* and the *Seattle Post-Intelligencer* (PI) whose works found their way into this book; and Dr. Jim Warren, whose book *The Day Seattle Burned* provided historic information. A final thank you goes to any contributor whom I have inadvertently forgotten to mention.

INTRODUCTION

A party of settlers landed on a small promontory jutting into Puget Sound in November 1851, although their settlement was not the first in the area as the city of Olympia was already a bustling town 60 miles south. The following spring, this party moved most of their settlement across Elliott Bay to its east shore, a more desirable harbor location. Soon others were attracted to the community, including a businessman named Henry Yesler, who built the first steam-powered sawmill on the sound. They named the new settlement for an amicable old Native American chief in the region. It grew.

Seattle was incorporated as a city in 1869. In the next year's census, it had a population of 1,151. The year 1870 also saw an attempt to form a fire department when, in July, a volunteer hook-and-ladder company resulted from a meeting of leading citizens. They had buckets, ladders, and axes but no vehicle to transport this equipment. The first fire ordinance passed by the city council required each household and business to furnish a 40-gallon barrel of water for use by the volunteers and levied a $10 fine for each day the household or business was not in compliance.

The volunteers soon grew tired of carrying their equipment by hand on the hilly streets, and mud resulting from the frequent wet weather did not help matters. They elected to build their own wagon to carry the gear but needed a craftsman to construct the four wheels, and they petitioned the city council for the funds to buy them. The city council refused, and the volunteers disbanded in disgust.

In 1876, a fire destroyed T. P. Freeman's store on Commercial Street (now First Avenue South). This spurred the citizenry to create a formal volunteer fire department, the one from which today's professional fire department was formed. Here is that story.

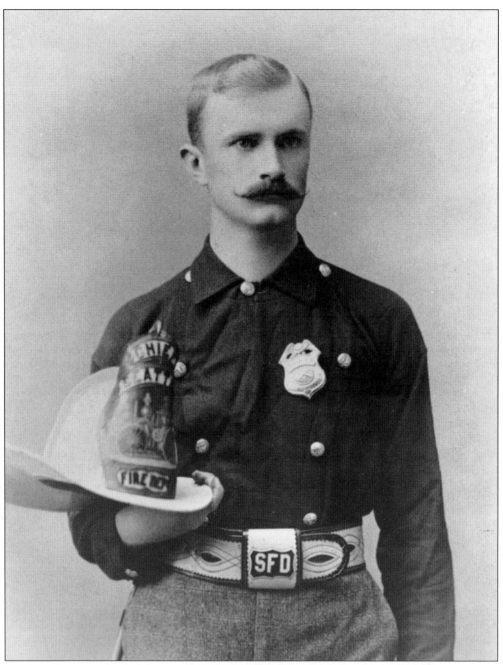

Josiah Collins was chief of the Seattle Volunteer Fire Department at the time of the great fire in June 1889. However, he never saw the fire. A few days earlier, he and his family had set sail for San Francisco to attend a wedding. (Courtesy of MOHAI, 17665.)

One

VOLUNTEER DAYS

Seattle Engine Company No. 1 came to life at a meeting of citizens on July 6, 1876. A constitution was written, officers elected, and money for equipment was obtained by subscription. A used Hunneman end-stroke hand-operated pumper was purchased from the Sacramento Fire Department, and a hose reel was borrowed from the Port Gamble Volunteers across Puget Sound. The apparatus was housed in a shed on the Hinckley property at the southwest corner of Second and Columbia Streets, and the volunteers were in business.

By 1878, sufficient funds were available to purchase a new steam pumper capable of delivering 550 gallons of water per minute. Bought for $3,500 from the Gould Company of Vermont, it arrived by ship on February 1, 1879, and the steamer was paraded through town. The parade was followed by a celebration that included a dinner hosted by the ladies of Seattle and a dance at Yesler's Hall.

On the evening of July 26, 1879, a major fire destroyed Yesler's Wharf at the foot of Mill Street (today's Yesler Way). The new steamer worked well drafting from the bay until a liner in the suction hose loosened and plugged the pump's intake. The old hand pumper was once again summoned and put to work.

In the 1880 Census, the population of Seattle was 3,553. A new fire station was built in 1883 for the Seattle Engine Company on Columbia Street between Front (now First Avenue) and Second Streets. In 1884, the city formally took control of the volunteer fire department through an ordinance passed on April 11. Gardner Kellogg, a druggist who had been active in the early Chicago Fire Department, was selected as the chief. He was replaced by Josiah Collins on May 13, 1888.

Other volunteer fire companies had joined the Seattle Engine Company over the years, including Hyak Hose Company No. 1, which shared the Columbia Street quarters with the Seattle Engine Company. By June 1889, the list of companies also included Washington Engine Company No. 2 and a hook-and-ladder company at the city hall, Union Engine Company No. 3 on the Western Mill property, Belltown Hose Company No. 4, and Deluge Hose Company No. 7 in the old North School. However, providence had plans for the city that month that would bring an end to the volunteer era.

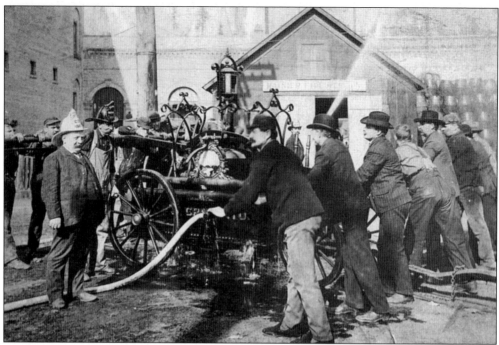

The Hunneman hand-operated pumper, which was bought from the Sacramento Fire Department, served at several volunteer companies in Seattle before it was sold. It is pictured here at one of its "hand-me-down" fire brigades after 1910. (Courtesy of LRFD.)

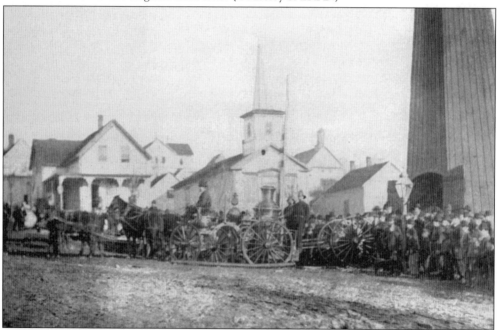

Seattle Engine Company No. 1's original quarters were in the shed with the tower, possibly a windmill, on the Hinckley property at the southwest corner of Second and Columbia Streets. Pictured here is the 1878-built Gould steam pumper, which was capable of delivering 550 gallons of water per minute. (Courtesy of SFD.)

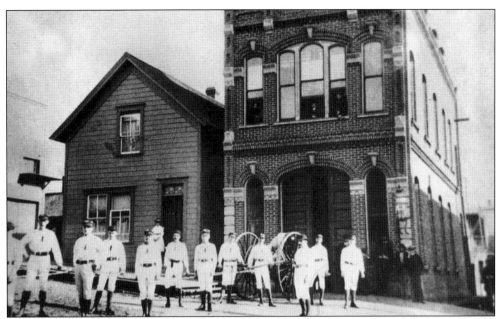

The Seattle Volunteer Fire Department's Muster Team is pictured here with their hose reel. Volunteers from the various cities and towns in the territory would hold competitions, which included hose-cart races, make-and-break hose coupling, and timed trials for supplying water to a nozzle. This fire station on Columbia Street, a few doors west of Second Street, was built in 1883 to replace the Hinckley shed. (Courtesy of LRFD.)

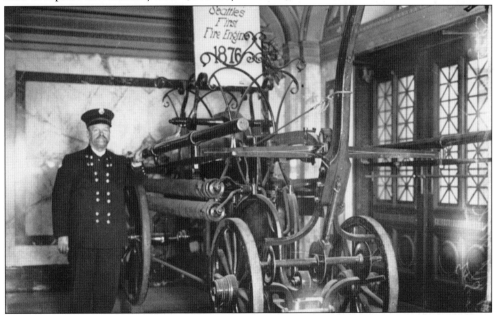

After having spent its useful life at various fire agencies in western Washington, Seattle's original hand pumper was rediscovered stored in a warehouse during the 1920s. Seattle officials obtained the vehicle as a museum piece, and it is pictured here on public display under the watchful eye of assistant chief William Clark. As a teenager, Chief Clark had run with the crew of Seattle Engine Company No. 1 and was quite familiar with this old machine. (Courtesy of MOHAI, 122785.)

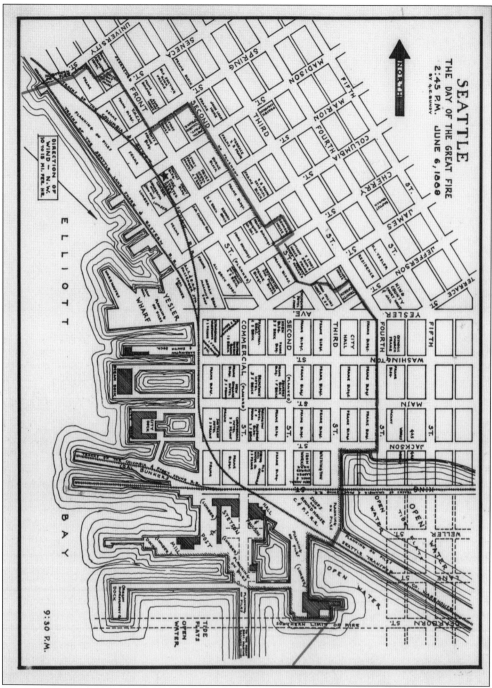

This map drawn by the late Lt. George Bundy shows the extent of the fire's devastation as defined by a line running from Elliott Bay at University Street to the open water south of the Columbia and Puget Sound Railroad's shops and roundhouse. Note the starting point at Front and Madison Streets (marked by the star). The direction of the destruction was basically south and east as fanned by the wind. (Courtesy of SFD.)

Two

THE GREAT FIRE

It had been unusually hot and dry that spring of 1889, and on the afternoon of June 6, a noticeable breeze blew from the northwest off Elliott Bay. At about 2:45 p.m., a fire alarm was received for Front (now First Avenue) and Madison Streets. A fire had started in a basement cabinet shop in the Pontius Block on the southwest corner. An employee had thrown a bucket of water onto a glue pot, which had ignited while being heated on a stove. The glue overflowed and fire spread through the shop. Because of the grade, the rear of the basement opened over the bay, and the breeze through the open back windows fanned the flames. The fire was on its way.

The early water mains were insufficient for supplying more than one hose line. When the steam pumpers tried to draft water from the bay, they experienced difficulty maintaining a draft because the tide was low at the time. Fire spread into all the buildings on the block. Before long, the radiant heat ignited the exterior of the Frye Opera House across Front Street. Fire was also spreading to the buildings across Marion Street one block south.

Because of Chief Collins's absence, assistant chief James Murphy was in command of the operations. As the fire spread south and east from block to block, Mayor Robert Moran took command and moved the fire companies east to Third Street. He began dynamiting buildings in the fire's path with only limited success. Help arrived by train and by sea from many other fire departments, including those in Tacoma, Snohomish, Bellingham, Port Townsend, and even Portland, Oregon, and Victoria, British Columbia.

Toward evening the breeze had calmed, and the fire's spread was checked by 9:30 p.m.; it had been kept from crossing Third Street. Still, 31 square blocks of the heart of the town lay in ashes, including two fire stations. Later that month, a temporary structure with a canvas roof was provided at Third and University Streets for the burned-out fire companies.

The insurance industry blamed the city for not providing an adequate water supply, an adequate fire department, or any training for that department, and many of the volunteers resigned because of the ill will generated by those charges. Chief Collins himself quit on July 10. He was replaced by Jack McDonald, who resigned in September. Finally, on October 17, the city council passed Ordinance No. 1212, which created a paid, professional fire department.

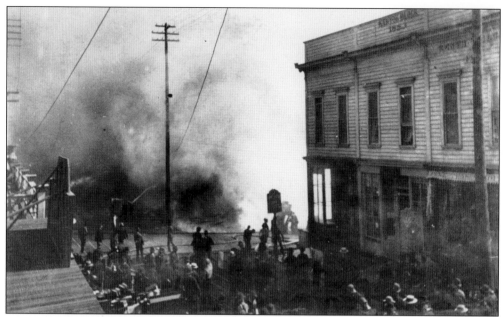

Taken diagonally across the intersection of Front and Madison Streets, this photograph shows the Pontius Block engulfed in smoke not long after the fire's start. Crowds looking south on Front Street watch the spectacle. (Courtesy of MOHAI, 6395.)

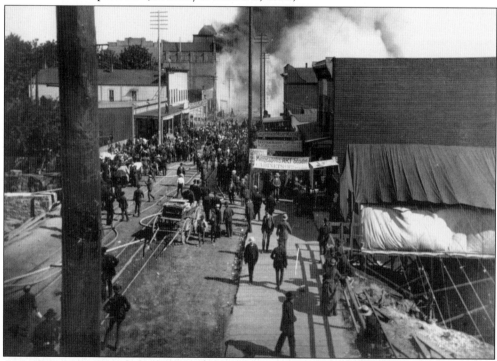

Approximately half an hour after the alarm had sounded, the exterior of Frye's Opera House across Front Street from the Pontius Block burst into flames. The opera house stood out because of its large mansard cupola. By the time the fire was controlled, everything in the foreground of this photograph had been reduced to ashes. (Courtesy of MOHAI, 9587.)

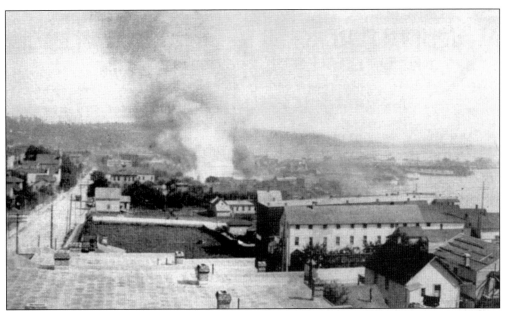

Smoke rises from the intersection of Front and Madison Streets about 45 minutes into the operation. An unidentified photographer snapped this image from a rooftop on the west side of Second Street near Pike Street. (Courtesy of SFD.)

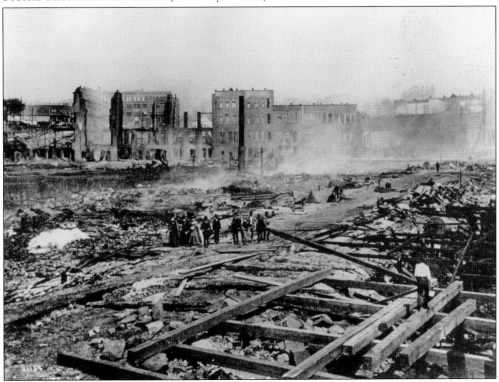

The remains of the brick buildings on Front Street are seen here from the ruins of Yesler's Wharf. Henry Yesler's mansion at Third and James Streets, which escaped the flames, is visible on the horizon to the far right. (Courtesy of MOHAI, SHS 705.)

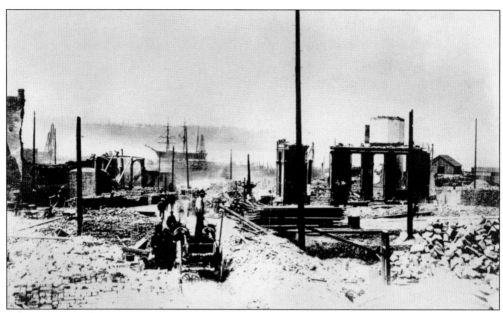

Looking toward the waterfront, the destruction was very evident as well. The first order of business in the rebuilding process was removal of all debris. (Courtesy of MOHAI, 11595.)

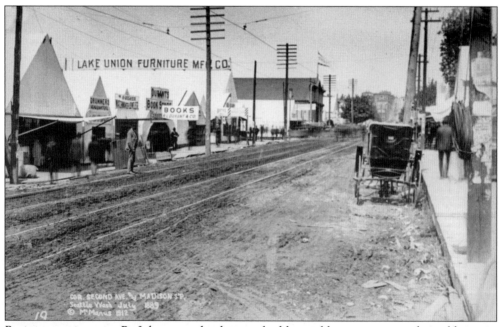

Business was in tents. By July, many shopkeepers had been able to reopen on their old sites in temporary quarters. This image looks north on Second Street near Madison Street. (Courtesy MOHAI, 1253.)

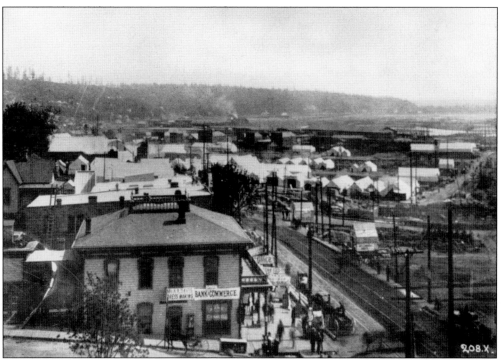

Canvas buildings outnumbered wood or masonry structures in the Seattle business district in the months following the fire. This photograph facing south from Second and Cherry Streets shows that the bay still covered what would eventually become the industrial area south of downtown. (Courtesy of MOHAI, SHS 701.)

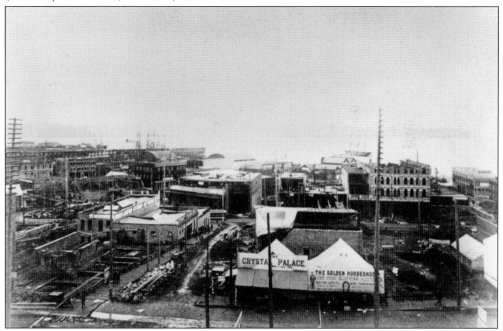

Permanent buildings quickly replaced the tent structures in the year following the great fire, as evident here looking west from Third and Jefferson Streets. (Courtesy of MOHAI, 2168.)

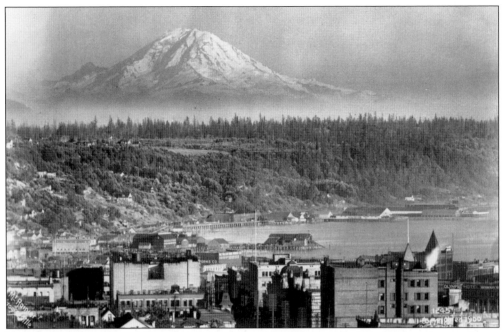

During the 10-year period following the fire, the city had been rebuilt in brick and stone. It was larger than it had ever been before, achieving 80,000 residents by 1900. This photograph shows that the bay still reached the foot of Beacon Hill and that industry was moving south down the shoreline. Residences also sprung up on Beacon Hill as the city grew. The photograph, taken around 1900 from the top of Denny Hill (about Third Avenue and Virginia Street), faces south along a line just to the east of Second Avenue, the street travelling away from the photographer in the picture's center. (Courtesy of MOHAI,, 88.33.8.)

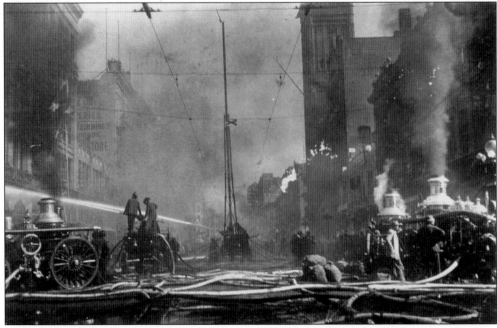

Fire apparatus block First Avenue at a blaze around 1906. (Courtesy Local 27.)

Three

HEYDAY OF THE HORSE

Gardner Kellogg, the first chief of the volunteers, was selected to lead the new department. Appointed on October 22, 1889, he spent the next several days in the temporary fire station interviewing candidates for the 32 positions. The Seattle Fire Department went into service on a single platoon basis at 8:00 a.m. on October 26.

Washington Territory became a state on November 11, 1889, and Seattle's population was 42,837 by 1890. Ten new fire stations were built in the next few years. The department experienced its first line-of-duty fatality on March 9, 1891, when Herman Larson of the fireboat died of injuries sustained during a drill three days earlier; he was thrown off a pier by a charged hose line that had gotten loose.

Because of the political nature of the position, a succession of fire chiefs began to take place. Chief Kellogg was replaced by Capt. Al Hunt on November 1, 1892, because Kellogg had been a staunch advocate of fire-prevention measures that the business community thought too harsh. Less than two years later, Chief Hunt returned from travelling to find that he had been replaced by Alex Allen, who was himself replaced after only four months. Ralph Cook took the job on July 20, 1895, and served almost a year. As people became tired of the politics, which was occurring in all departments, they pressured the city to adopt a new charter that included civil-service status for all employees. Gardner Kellogg was given his old job back, becoming chief for the second time on June 19, 1896.

Seattle's 1900 population stood at 80,671. Chief Kellogg stepped down on February 1, 1901, to take the newly created position of fire marshal, the person who would be charged with enforcing the fire ordinances. Chief Cook again led the department until December 29, 1906, when Harry Bringhurst, a civil engineer, became chief.

By 1910, Seattle's population was 237,194 and Hiram Gill, the newly elected mayor, found reason to replace Chief Bringhurst with Capt. John Boyle. Because of his tolerance of vice, Mayor Gill was out of office by 1911 and so was Chief Boyle, but no one wanted the job. Assistant chief William Clark filled in until Frank Stetson, a retired chief from Minneapolis, was drafted into the position. He accepted, provided he was given no interference. Hard "electioneering" by firefighters won passage of a ballot measure in 1912 to create a two-platoon work schedule, which shortened working hours considerably.

The first motor vehicle in the fire department was a 1907 Autocar runabout, purchased for use by the chief. In 1910, several motorized fire trucks went into service, and by 1914, motor power was well on its way to replacing horsepower.

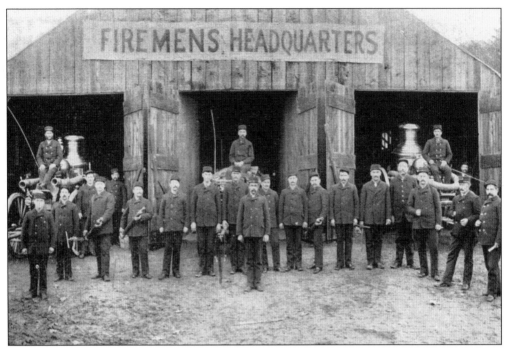

Fire chief Gardner Kellogg (second from right) poses with his entire new fire department in front of the temporary fire station at Third and University Streets. On the far right is assistant chief Carl E. Bassler, second in command. (Courtesy of SFD.)

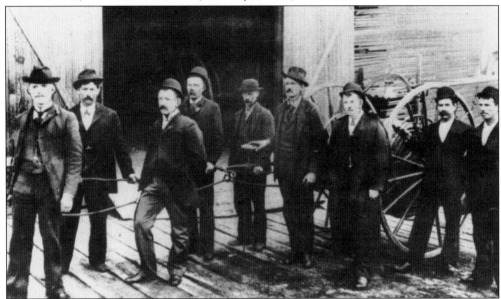

After the annexation of the Fremont district in 1891, there were no resources for a paid fire company in the north end of the city. The Fremont Volunteers were organized under the jurisdiction of the Seattle Fire Department as Hose Company No. 8 to fill that void. Here they pose in front of their quarters on the Bryant Lumber Mill property with one of their two hand-drawn hose reels. They were disbanded in 1901, when a paid fire company was organized in a new station a few blocks up Linden Avenue. (Courtesy of MOHAI, SHS 9594.)

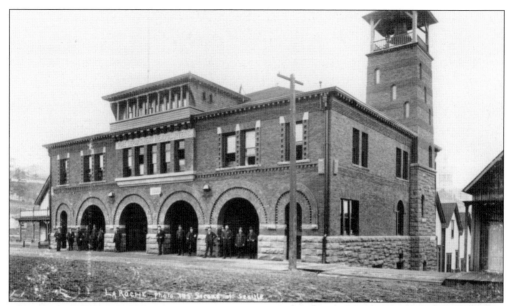

The new headquarters fire station opened in November 1890 at Seventh Avenue and Columbia Street. Being on a dead-end street, the companies had to travel Seventh Avenue either north to Madison Street or south to James Street to respond downtown. The lack of a downtown fire station was solved in 1903, when a new headquarters station went into service at Third Avenue South and Main Street. This building then became a neighborhood fire station on First Hill. (Courtesy of MOHAI, 163.)

Chief Kellogg is pictured here in his fire-department buggy in front of Station No. 1 in 1901. (Courtesy of MOHAI, 88.33.83.)

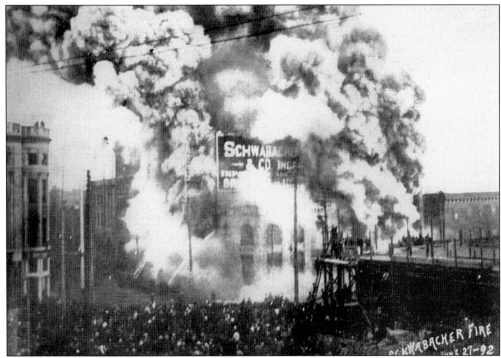

A major fire heavily damaged the Schwabacher import company on June 27, 1892, and a crowd of onlookers blocked First Avenue at Yesler Way to watch the spectacle. (Courtesy of SFD.)

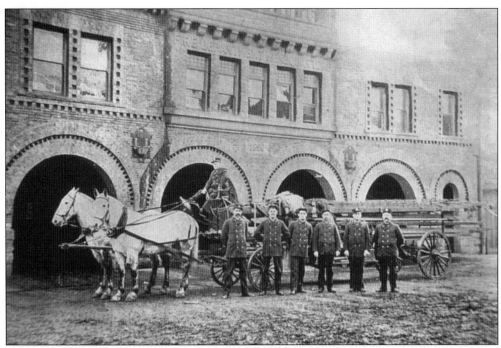

The 1889 Preston truck with a 65-foot aerial ladder was placed in service at Station No. 1. (Courtesy of SFD.)

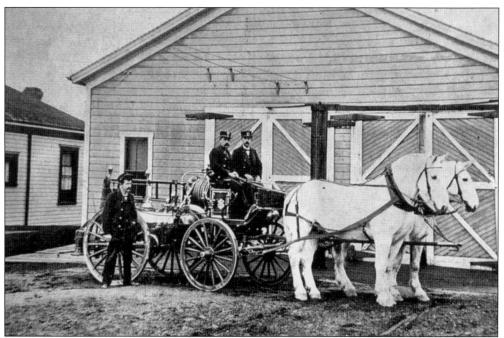

The first fire station on Queen Anne Hill was this modest one-story frame building at First Avenue West and West Lee Street, where St. Anne's School stands today. It housed Chemical Company No. 3, which used this 1891 Holloway chemical engine. (Courtesy of SFD.)

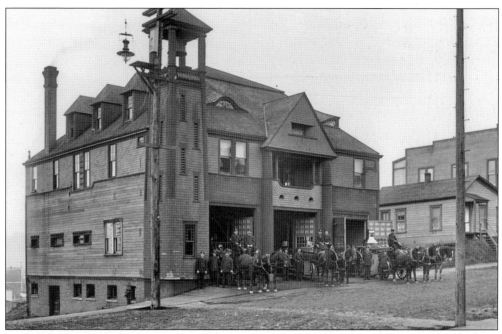

Fire Station No. 4 was built in 1890 at the northeast corner of Fourth Avenue and Battery Street on the north slope of Denny Hill. It housed Engine Company No. 4 and a ladder truck. The station was used only until 1908, when the hill was regraded, and a new station was built several blocks north. (Courtesy of MOHAI, 88.33.85.)

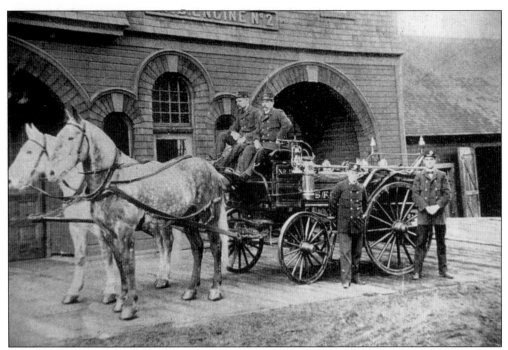

In 1901, Engine Company No. 2's hose wagon was posed in front of Station No. 2 at Third Avenue and Pine Street. Seated next to driver S. C. Hastings (left) is Capt. William Clark, who would serve as an assistant chief for many years. (Courtesy of SFD.)

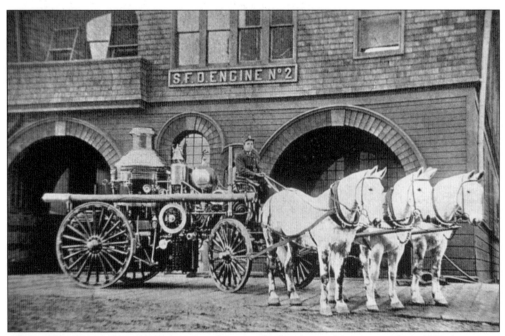

Also in 1901, Engine No. 2's steamer was photographed in front of quarters with its 1899 American Metropolitan steam pumper and a perfectly matched set of horses. (Courtesy of SFD.)

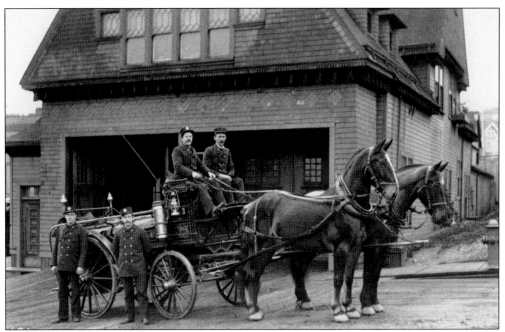

The hose wagon of Engine Company No. 3 is seen here in front of its Main Street station. The driver, John Boyle, would later spend a year as chief of the fire department. Seated next to him is Tom Nunan, who would rise to the rank of assistant chief. The firefighters standing are F. M. Collins (left) and D. Cook. (Courtesy of MOHAI, 88.33.87.)

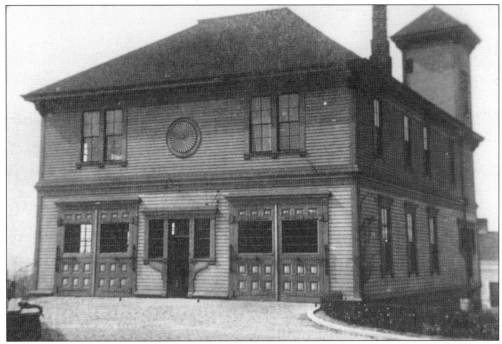

Fire Station No. 6 at Twenty-third Avenue South and East Yesler Way was built in 1894. The station was razed for the construction of the present Fire Station No. 6, which opened in 1932. (Courtesy of LRFD.)

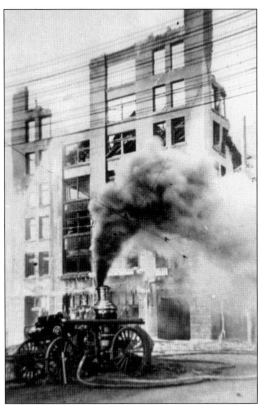

A steam pumper is working at the corner fire hydrant on First Avenue as a second major blaze at Schwabacher and Company in 1905 destroys the building. (Courtesy LRFD.)

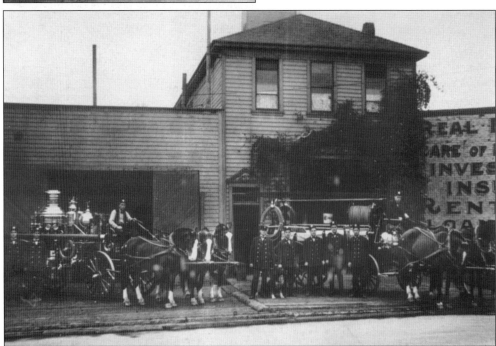

The city of Ballard was annexed into Seattle on June 1, 1907. This Ballard firehouse at 5431 Russell Avenue became Station No. 18 in the Seattle Fire Department. (Courtesy of LRFD.)

With their new water tower, firefighters battle an early 20th-century fire on First Avenue north of Yesler Way as spectators again block the street. (Courtesy of LRFD.)

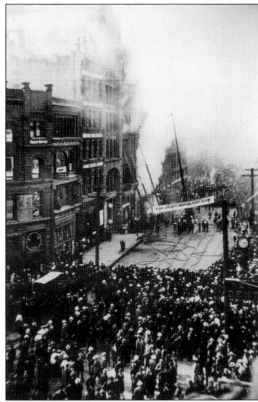

Because of the regrading of Denny Hill in 1908, Fire Station No. 4 was moved into this handsome structure. The most decorative of all Seattle's fire stations, it served as such only until 1921, when motorization of fire apparatus caused several fire stations to become obsolete. It became the Fire Alarm Center in 1925. (Courtesy of LRFD.)

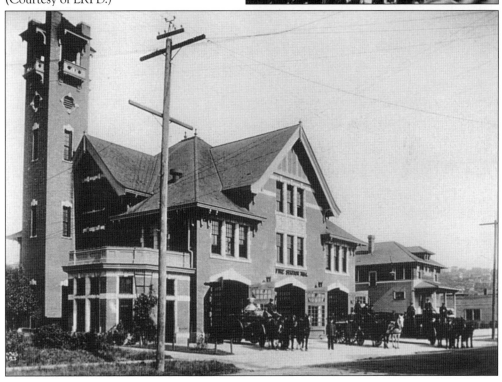

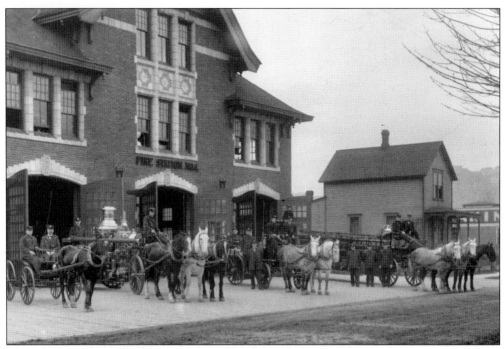

The engine company, ladder company, and battalion chief of Fire Station No. 4 pose in front of quarters on Fourth Avenue North between John and Thomas Streets. The Space Needle built for the 1962 World's Fair now stands on this site. (Courtesy MOHAI, 83.10.9399.1.)

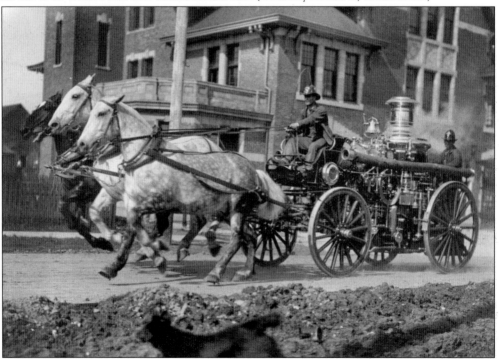

Engine Company No. 4's steamer, a 1906 Ahrens capable of pumping 700 gallons of water per minute, heads south on Fourth Avenue. (Courtesy of MOHAI, 83.10.8172.)

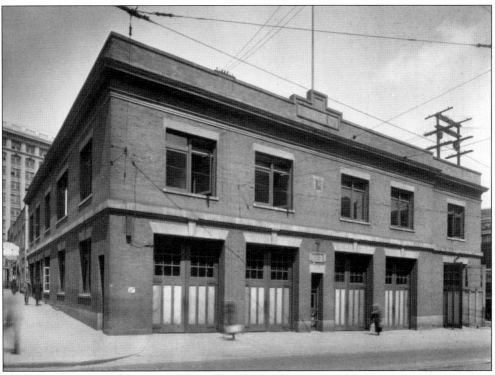

This 1906 replacement for Fire Station No. 2 at Third Avenue and Pine Street received a fifth apparatus bay (far right) in 1909 to house a ladder truck. (Courtesy of MOHAI, 83.10.2209.)

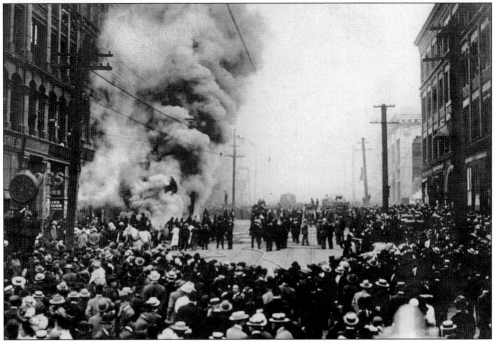

Smoke pours from the basement and first floor of this downtown building during a major fire in the 20th century's first decade. (Courtesy of LRFD.)

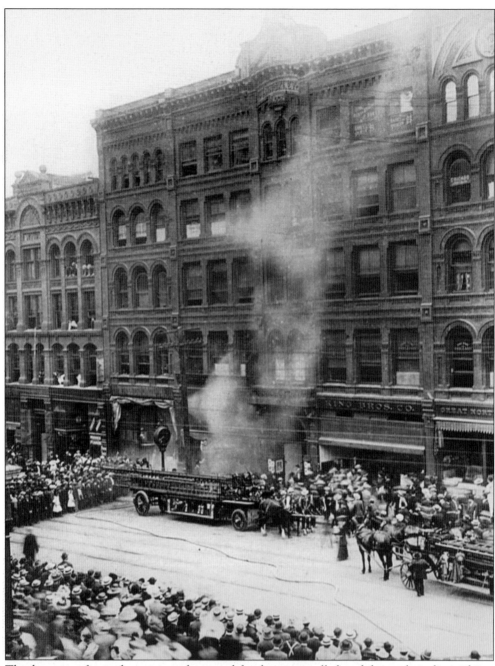

The downtown fire in the previous photograph has been controlled, and the smoke is diminishing. In front of the building is a 1906 American LaFrance 85-foot aerial-ladder truck. (Courtesy of LRFD.)

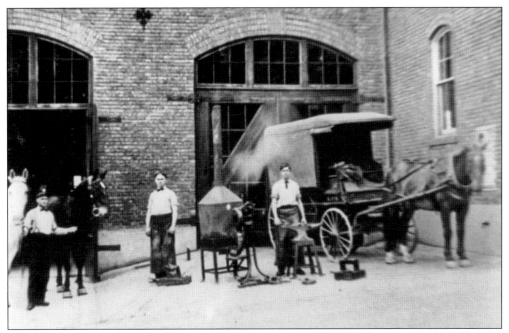

The fire-department blacksmith's job was to provide shoes for all the horses, and in 1910, his shop was located in the basement of the new Fire Station No. 25. The blacksmith is pictured with his wagon, his assistant, and an array of his equipment in front of that station. Two of his "clients" are being led out to meet him. (Courtesy of LRFD.)

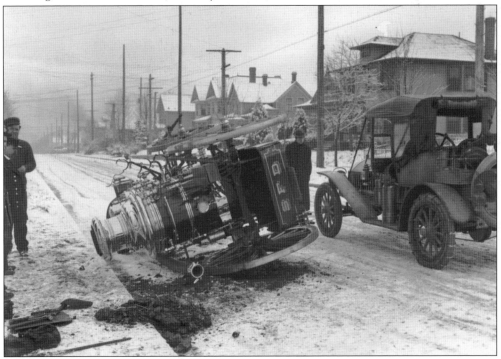

On a snowy day around 1913, Engine Company No. 6's steam pumper failed to make the corner, and the result is pictured here. (Courtesy of MOHAI, 83.109113.1.)

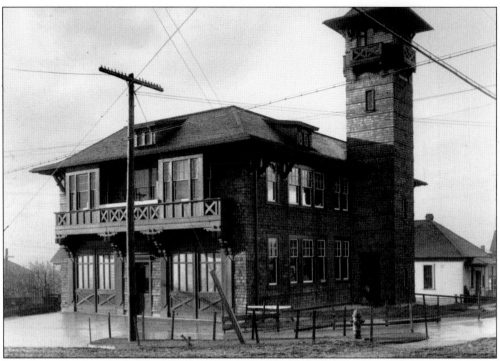

Fire Station No. 22 opened in 1909 at the corner of Eleventh Avenue East and East Howe Street to serve the north end of Capitol Hill. (Courtesy of MOHAI, 83.10.8738.1.)

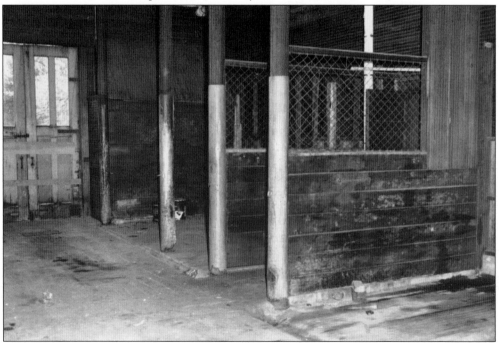

When Fire Station No. 22 was closed in 1964, its horse stalls were still intact. A fire department photographer, knowing the building would soon be demolished, took this photograph as a permanent record of their appearance. (Photograph by Ray Kirlin; courtesy of SFD.)

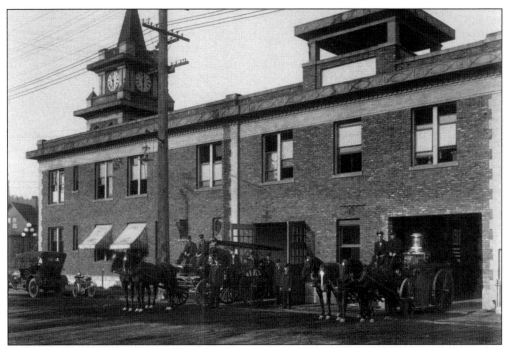

In 1910, the city of Georgetown was annexed into Seattle along with its city hall and fire station. The city hall (left) became a police precinct, and the fire station became home to Seattle Fire Department Hose Company (later Engine Company) No. 27. (Courtesy of MOHAI, 83.10.10192.)

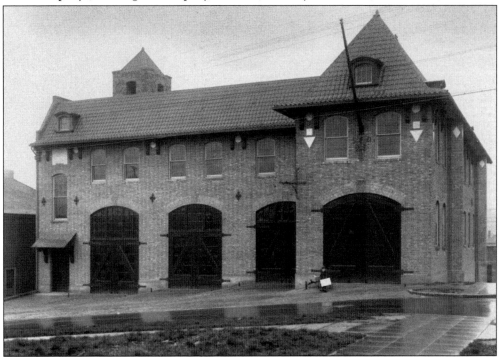

Fire Station No. 25 opened its doors in June 1910 at 1400 Harvard Avenue. Replaced in 1970, this structure still stands as a townhouse apartment building. (Courtesy of MOHAI, 83.10.8737.)

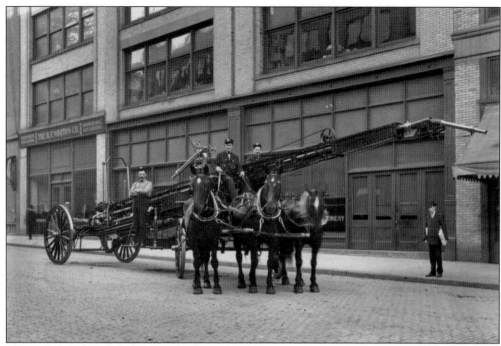

The fire department placed this Champion 65-foot water tower into service in 1905. It had an 1,100-gallon-per-minute deck monitor mounted behind the driver. In 1916, the horses were replaced with a Seagrave motorized front-drive tractor. (Courtesy of MOHAI, 83.10.7896.1.)

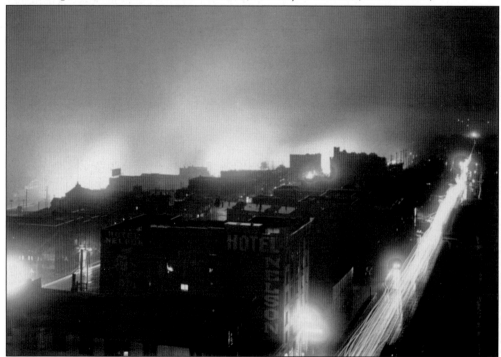

A large fire, viewed here from the Moore Theater Building at Second Avenue and Virginia Street, destroyed a block of the Belltown neighborhood in 1910. (Courtesy of MOHAI, 83.10.8942.1.)

Driver Bill Rouillard of Engine No. 15 is pictured here with Blackie and Dimple. Rouillard remained a driver at Station No. 15 after the switch to motorized fire apparatus in 1920. (Courtesy of Betty Stanton.)

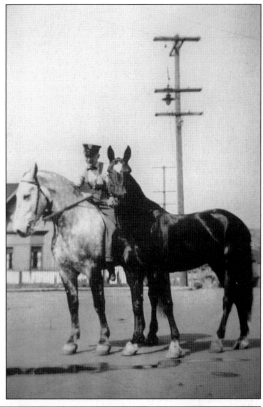

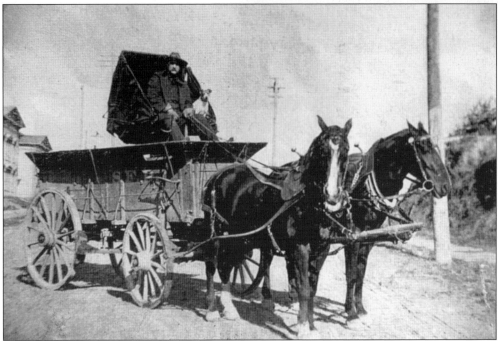

The fire department's supply wagon is pictured here at Fifth Avenue and Wall Street. The driver is J. D. Phillips, who came to the fire department from the police department. (Courtesy of SFD.)

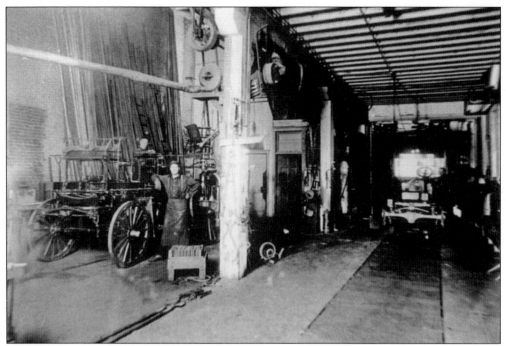

The repair shop was a feature of Fire Station No. 2 at Third Avenue and Pine Street when it was built in 1906. In its later years, it serviced both horse-drawn and motorized apparatus. (Courtesy of LRFD.)

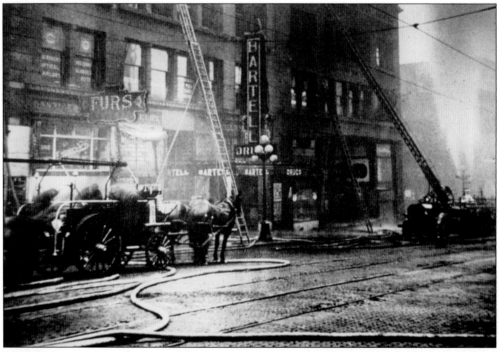

Firefighters mop up at the scene following a 1913 fire in the *Seattle Times* Building at Second Avenue and Union Street. (Courtesy of LRFD.)

Four

THE MOTOR ERA BEGINS

By the end of 1914, there were 33 fire stations in Seattle, including two with fireboats. On the afternoon of July 30, 1914, a fast-moving fire destroyed the Grand Trunk–Pacific Railroad's ornate pier just south of the downtown fireboat station. At the time, it was the largest wooden pier on the Pacific coast. Around 3:40 p.m., smoke was seen coming from under the pier's south side and the alarm was given. About five minutes after smoke began to rise through the wooden floor, fire flashed over the entire interior of the warehouse, trapping two firefighters and burning both of them badly. Patrick Cooper died three days later, and the other firefighter, John Stokes, was permanently disabled. The heat was so intense it ignited the Coleman Dock 167 feet to the south and the Galbraith-Bacon Dock 140 feet to the north. Besides firefighter Cooper, four other people on the dock were killed. Another 29 people were injured, including 10 firefighters.

February 18, 1918, was the beginning of the International Association of Fire Fighters, and Seattle's own Local 27 was one of the union's 218 charter members on that day. The Seattle local was formed from the former City Fire Fighters' Union No. 15462 of the American Federation of Labor's miscellaneous trade unions.

The 1920 Census gave Seattle a population of 315,312. Chief Stetson retired on October 2,1920, and was replaced by George Mantor, a career firefighter who had joined the Seattle Fire Department in March 1896. During World War I, he served in the army as fire chief of the base at Fort Lewis, south of Tacoma. As Seattle's chief, he published a set of rules and regulations to guide the day-to-day running of fire-department operations.

Twelve new pumpers and five new ladder trucks were placed into service in 1924, thus completing the motorization of the fleet that had begun in 1910. A 1926 survey by the National Board of Fire Underwriters raised Seattle's fire-insurance classification from a Class III to a Class II, with a subsequent lowering of all insurance rates. By the end of the decade, the fire department had taken delivery of several new pumpers, a new aerial-ladder truck, and a rescue squad. A new four-story headquarters fire station was built, as was a new fire station in the south industrial area with a seven-story tower for drills.

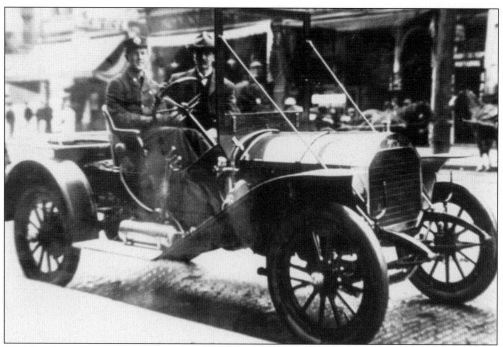

The fire department's first motorized vehicle was this 1907 Autocar runabout. Here Chief Harry Bringhurst is seated next to his driver. (Courtesy of LRFD.)

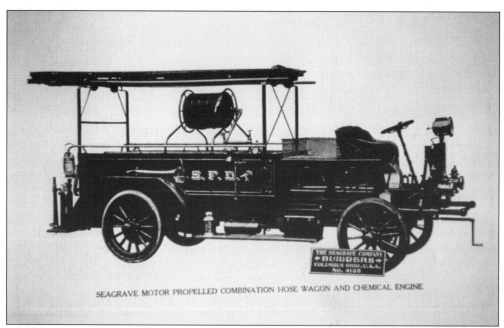

SEAGRAVE MOTOR PROPELLED COMBINATION HOSE WAGON AND CHEMICAL ENGINE

The first motorized fire truck to be used was this 1910 Seagrave hose wagon, placed in service on June 10, 1910, as Engine Company No. 25's hose wagon. Pictured here in a manufacturer's photograph, it carried a 40-gallon soda acid chemical tank and was powered by a 50-horsepower, air-cooled engine. (Courtesy author.)

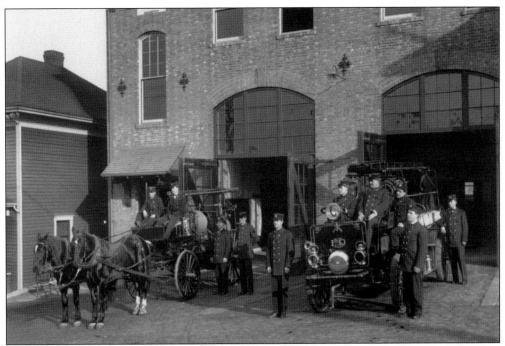

Both old and new are pictured here together at Station No. 25 in 1910. The new motorized Hose No. 25 on the right is quite a contrast to horse-drawn Chemical No. 2. (Courtesy of MOHAI, 83.10.9533.1.)

The Ballard district, annexed into the city in 1907, received added protection when this larger fire station opened in 1911 and a ladder company was included. In service until 1975, the station is pictured here in its last years. (Courtesy of SFD.)

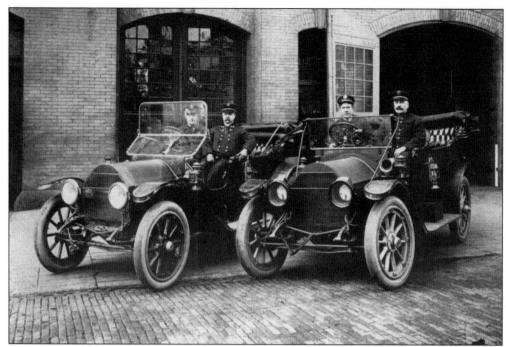

Two early Cadillac touring cars were purchased for the fire department. Chief Frank Stetson is seated with his driver in a 1913 model (right) while assistant chief William Clark poses with his driver in a 1912 model. (Courtesy of MOHAI, 2988.)

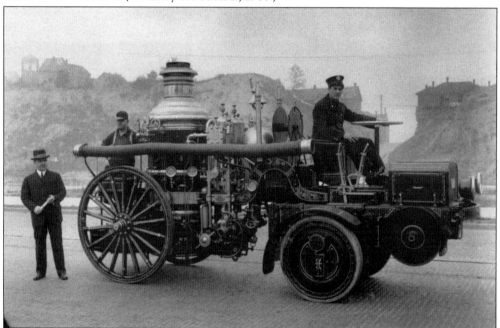

One way to extend the life of newer horse-drawn apparatus in the age of the motor was to install a motorized front-drive, two-wheel tractor. This 1914 Christie tractor, built by the Front Drive Motor Company, was attached to a 1907 American LaFrance Metropolitan 700-gallon-per-minute steam pumper. It saw service at Engine Company No. 14. (Courtesy of MOHAI, 83.10.9892.)

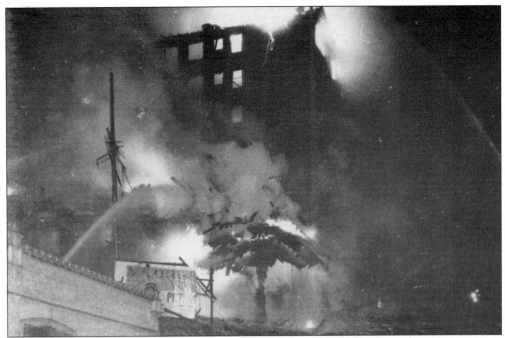

The Lincoln Hotel at Fourth Avenue and Madison Street was destroyed by a major fire not long after midnight on April 7, 1920. Three guests perished in the blaze, including two who jumped from the sixth floor into the rear alley. Firefighter Charles Lacasse was killed when the rear wall collapsed into that alley. The above view looks east from Third Avenue and was shot not long after the rear and south walls had collapsed. The lower view was photographed after dawn on April 7, looking east up Madison Street, the direction of the top image. Engine No. 10's 1904 Nott steam pumper is still hard at work at the Third Avenue and Madison Street fire hydrant. (Above courtesy of MOHAI, SHS 2127; below courtesy of MOHAI, 83.10.1870.2.)

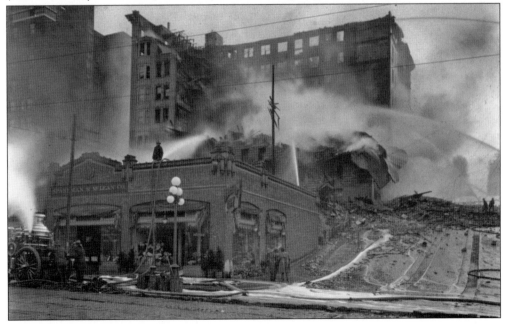

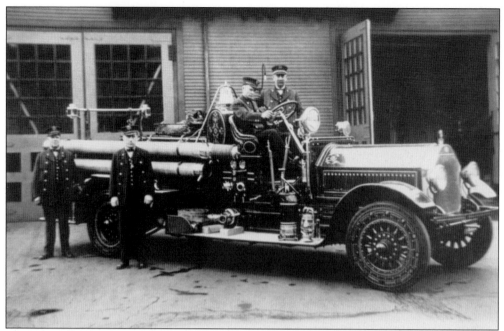

Engine Company No. 15 received a Seagrave 800-gallon-per-minute pumper in 1920. Here Bill Rouillard, who had previously driven the horse-drawn rigs, sits in the Seagrave with Capt. William Braun. Firefighters Harry Stanton (left) and Fred Richardson are standing beside them. (Courtesy of Betty Stanton.)

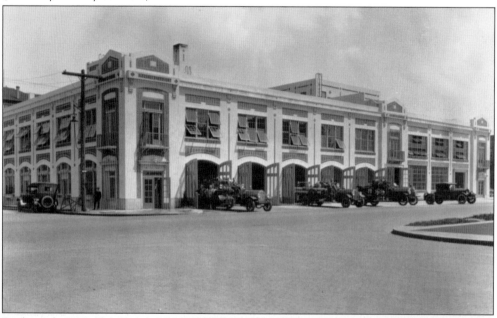

By the early 1920s, Fire Station No. 2's Third Avenue and Pine Street site had become increasingly congested. In April 1921, a new Fire Station No. 2 opened at the southeast corner of Fourth Avenue and Battery Street on newly regraded ground. The large building included a repair garage and utility shop in its south (right) end. The station is still in use as of this writing. (Courtesy of MOHAI, 83.10.2210.)

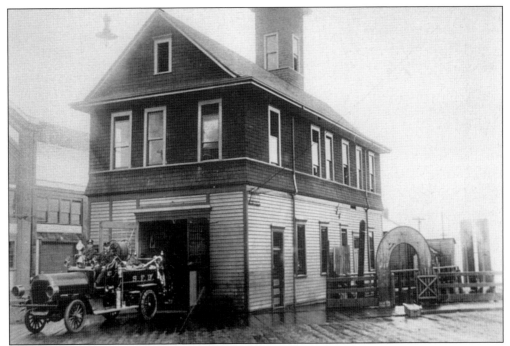

The hose wagon stationed at the foot of Madison Street with the fireboat received a 1911 Waterous motor wagon. When that truck was destroyed in the 1914 Grand Trunk–Pacific pier fire, a similar 1911 Waterous hose wagon (pictured here) replaced it. This hose wagon had a chemical tank. (Courtesy of LRFD.)

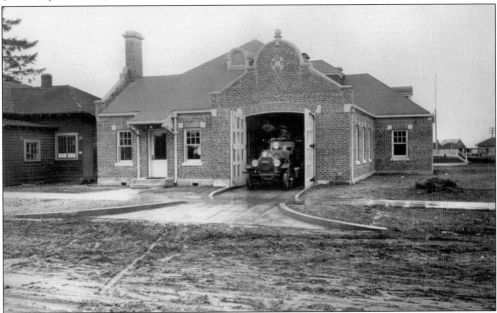

Several small, bungalow-style fire stations were built in the early 1920s to replace the older ones located in residential neighborhoods. This one at 2139 Ferry Avenue replaced the old wooden West Seattle fire station, seen here still standing on the left. West Seattle was annexed into Seattle in 1907. (Courtesy of Seattle City Archives, 2702.)

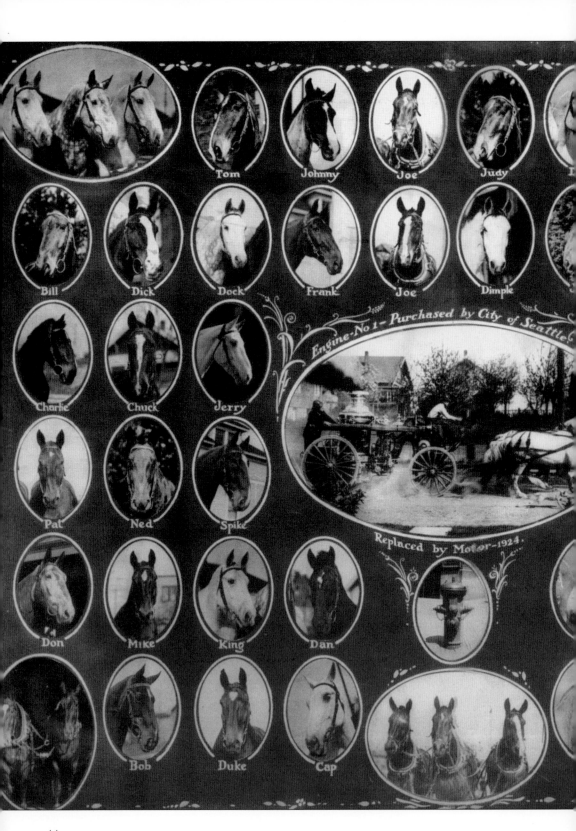

Tom Johnny Joe Judy

Bill Dick Dock Frank Joe Dimple

Charlie Chuck Jerry

Pat Ned Spike

Engine-No 1 - Purchased by City of Seattle

Replaced by Motor - 1924.

Don Mike King Dan

Bob Duke Cap

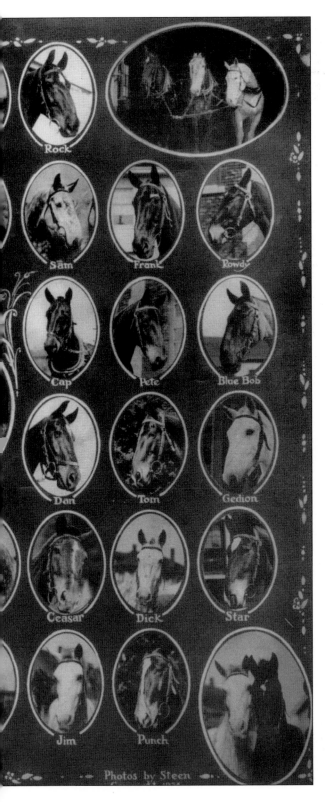

A class portrait was made of the fire horses of Seattle who retired in 1924. The photograph served as a sad reminder to fire-department personnel that the horses would never return. (Courtesy of LRFD.)

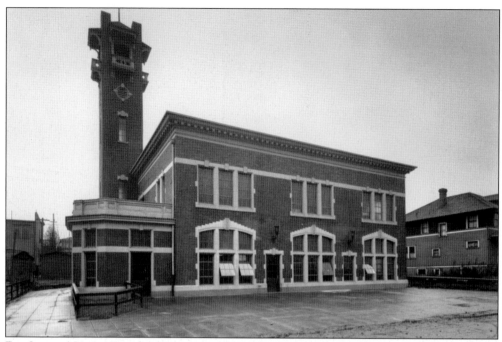

Fire Station No. 4 at Fourth Avenue North near Thomas Street was closed in 1921 because of the proximity of the new Station No. 2. It was rebuilt and converted for use as the Fire Alarm Center, opening in that capacity on October 7, 1925. The top view shows its much-changed appearance from that on page 27. The lower view shows how the interior of the main floor was used for the fire-alarm-box circuitry and the retransmitting gear. (Above courtesy of MOHAI, 83.10.3132.2; below courtesy of MOHAI, 83.10.3132.1.)

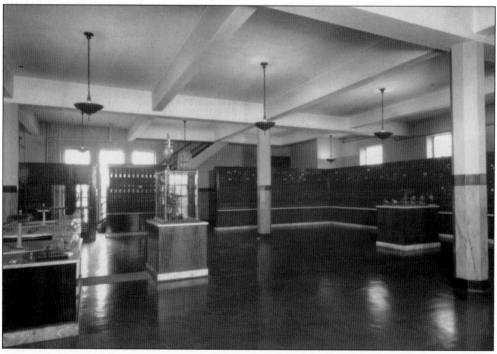

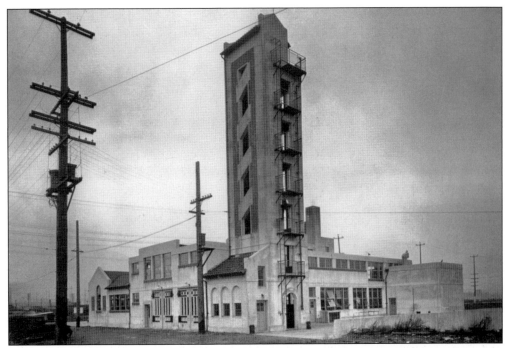

The large industrial area growing on reclaimed land south of downtown Seattle got its much-needed protection in 1927, when new Fire Station No. 14 opened at 3224 Fourth Avenue South. The facility included a seven-story tower, pictured here, for drilling purposes at the rear of the building. (Courtesy of Seattle City Archives, 2820.)

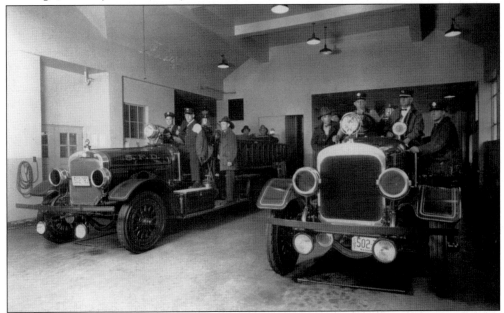

Completion of the new Station No. 14 allowed a ladder-truck company to be stationed in the industrial district. The 1924 Seagrave ladder truck is pictured here on the right, next to Engine Company No. 19's 1924 Seagrave 1,000-gallon-per-minute pumper. Both vehicles were part of an order that put the last horses out to pasture. (Courtesy of Seattle City Archives, 5915.)

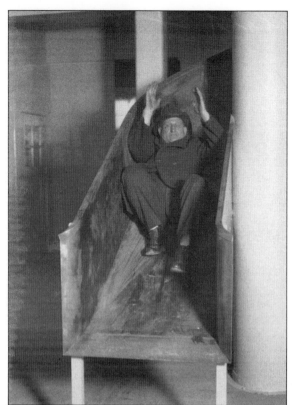

A feature of the new Fire Station No. 14 were chutes rather than sliding poles, allowing the firefighters a quick descent to the apparatus floor. Here a station member demonstrates the use of the chutes for the camera. This experiment proved less than satisfactory, and all the chutes were replaced with poles. (Courtesy of MOHAI, PI 22759.)

During 1928, the city extended Second Avenue from Yesler Way to Fourth Avenue South and Jackson Street. Pictured here is the work adjusting the old building facades to accommodate the new thoroughfare is in progress. Standing in the way of the project is the old fire-department headquarters, Station No. 10, at Third Avenue South and Main Street. By September, all the firefighters would be in a new, larger fire station one block west. The old station was then razed and the project completed. (Courtesy of MOHAI, 83.10.3507.)

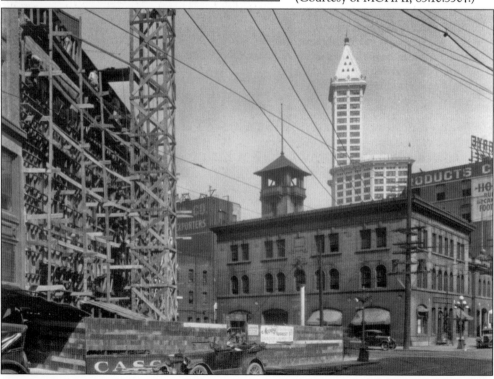

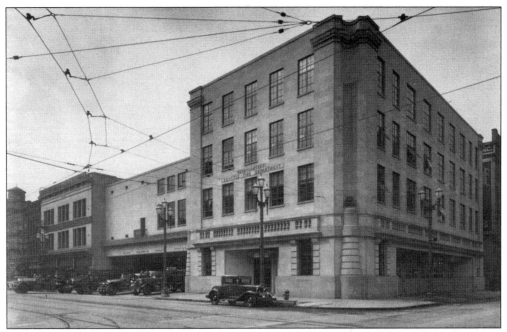

On September 24, 1928, the new fire-department headquarters, Station No. 10, opened on the southwest corner of Second Avenue South and Main Street. Though still in use as of this writing, a replacement for the fire station is under construction a few blocks away. The administrative headquarters will continue to operate out of this building. (Courtesy of MOHAI 83.10.3665.1.)

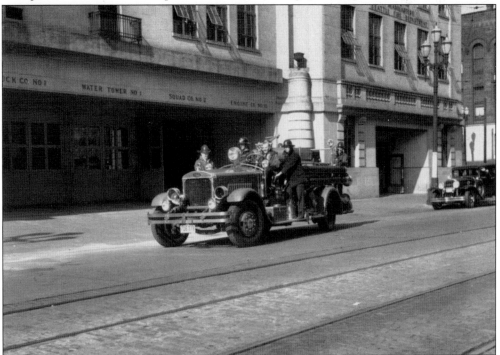

For many years after its purchase, this 1928 Mack pumper was assigned to Engine No. 10 in the new headquarters station. (Courtesy of MOHAI, PI 22792.)

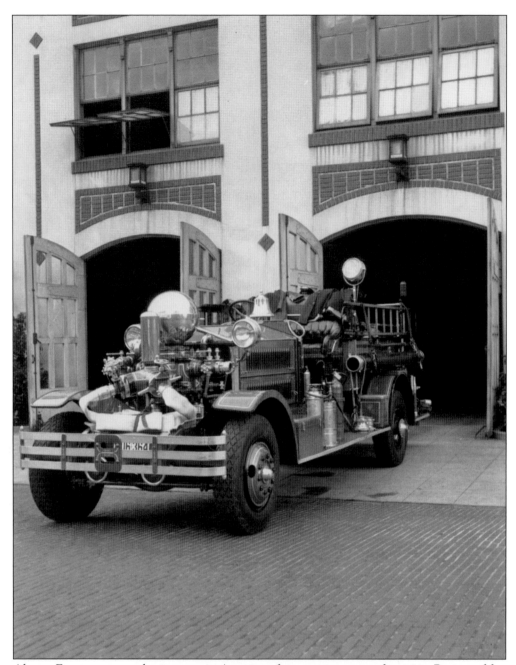

Ahrens-Fox was once a classic name in American fire-apparatus manufacturing. Rosters of fire trucks for some Midwestern cities show that Ahrens-Fox was once the dominant, or at least a major, supplier of their fire apparatus. Seattle only had one Ahrens-Fox, this classic NS-4 model delivered in 1927, pictured here as Engine No. 2 at the Fourth and Battery Fire Station. The trademark Ahrens Fox front-mounted pump is quite evident, with its large spherical surge tank, which was necessary to absorb the variations in pressure as the pistons operated. (Courtesy of MOHAI, PI 22789.)

Five

THE DEPRESSION AND WORLD WAR II

When the crash of 1929 triggered the Great Depression, Seattle was hit with the same hard times that the rest of the nation was facing. By 1930, the city had a population of 365,583. Chief George Mantor retired on February 20, 1931, and was replaced by Robert Laing, previously Seattle's fire marshal. Unable to purchase much in the line of new apparatus, he began a process of rebuilding and refurbishing older fire trucks in the department's shop. On June 6, 1932, Chief Laing returned to his former post of fire marshal, and Claude Corning became the new chief.

Chief Corning, faced with the bad economy, disbanded three fire companies on August 22, 1932, but the big blow came on April 4, 1933, when Mayor John Doran ordered 11 more companies closed with accompanying layoffs. Seattle's Local 27 of the International Association of Fire Fighters fought for the return of its members and an arrangement was worked out. One hundred eighty-six firefighters were rehired and seven companies reopened in January 1934. The remainder of the firefighters were rehired as openings occurred. Personnel were paid with the city's scrip.

As the state of the economy took its toll and the city struggled with antiquated fire equipment, the morale of the entire fire department was low. Mayor Art Langlie removed Chief Corning on April 26, 1938, and replaced him with battalion chief William Fitzgerald. In the 1930s, the fire department developed its aid cars, which were former chiefs' automobiles equipped with first-aid kits and old Pulmotor resuscitators and staffed by two firefighters. By 1938, Seattle had three such aid cars in service.

The city had a modest population increase in 1940 to 368,302, and the war in Europe was starting to breath some life back into the local economy. America's entry into the war greatly increased local business, including shipbuilding and aircraft manufacturing at the locally owned Boeing Aircraft Company.

The largest loss of life in a Seattle fire occurred because of the war. On February 18, 1943, an experimental Boeing B-29 bomber developed engine trouble during a test flight. Attempting to return to Boeing Field Airport, the plane fell short, crashing into the Frye Company's slaughterhouse and meatpacking plant on Airport Way. Thirty-two people were killed, including firefighter Luther Bonner, and 35 were injured, with eight of those being firefighters.

With help from the federal government, Seattle was able to acquire one new pumper truck during the war, and a new residential ladder truck was built in the department shop. With the city's financial future looking bright again, Chief Fitzgerald was looking to improve his department with new equipment and techniques.

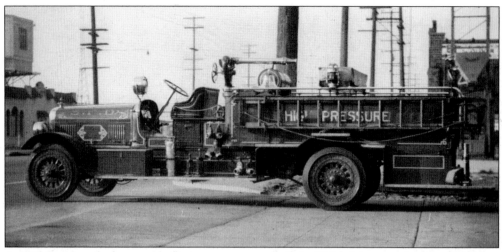

A 1916 Seagrave fireboat tender/hose wagon was rebuilt in 1931 with a more modern front but retained its original spoked wheels and hard rubber tires. It served its last years as a high-pressure hose wagon. (Courtesy of LRFD.)

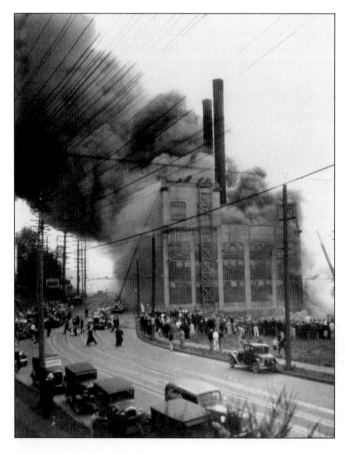

A blaze on April 30, 1935, at the Lake Union Steam Plant began as a grass fire beneath the Fairview Avenue trestle. Two workmen trapped on the roof were rescued via an aerial ladder. (Courtesy of MOHAI, PI 22866.)

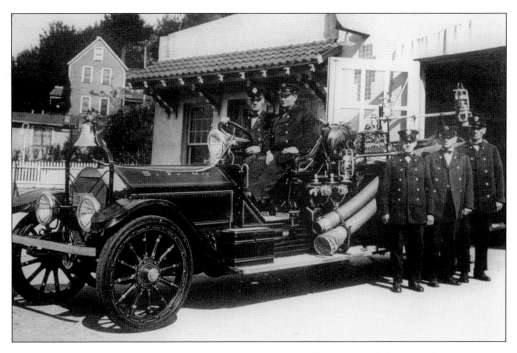

The Depression meant tight belts for municipalities across America, and this translated into little money for new fire apparatus. Seattle Fire Department's shop rebuilt a number of old trucks and gave them a new look to boot. Pictured above is a 1918 American LaFrance 1,000-gallon-per-minute pumper as it appeared when new. The photograph below shows it after a 1936 remodeling. Note that it was even converted from right-hand to left-hand drive. (Both courtesy of LRFD.)

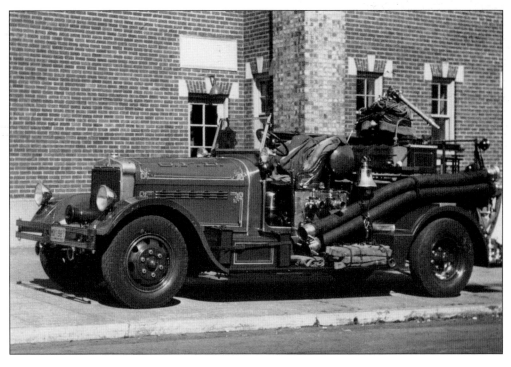

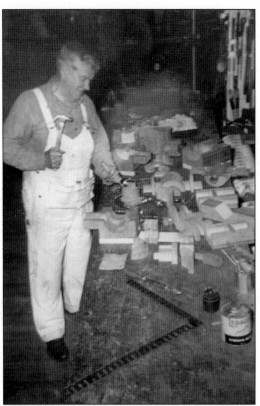

Firefighter Harry Stanton was reassigned from Engine Company No. 15 to the fire-department shop. Pictured here at his work station, he built many of the patterns used. (Courtesy of Betty Stanton.)

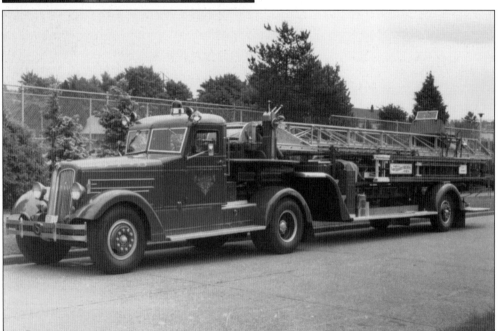

The first metal aerial ladder in the Seattle Fire Department could reach 100 feet, or seven stories. It was built by the Seagrave Corporation of Columbus, Ohio, and saw service from 1937 to 1970. It has been preserved and is maintained by the Last Resort Fire Department. (Courtesy SFD.)

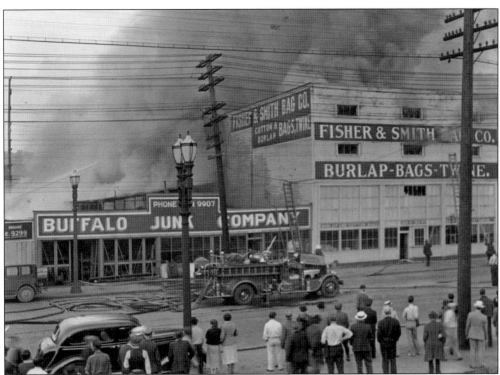

Two firefighters were injured in this blaze on June 11, 1937. Starting in the salvage warehouse at 1550 First Avenue South, it spread to the Fisher and Smith Bag Company where burlap grain sacks were reconditioned. (Courtesy of MOHAI, PI 22871.)

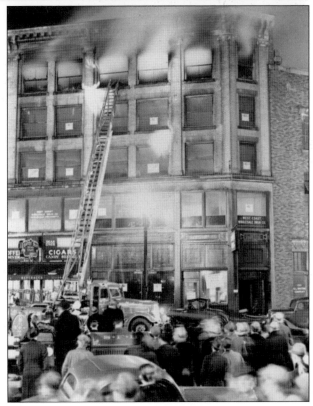

Firefighters battle an evening blaze on January 19, 1938, that gutted the top floor of this clothing warehouse at 311 Third Avenue South. (Courtesy of MOHAI, PI 22882.)

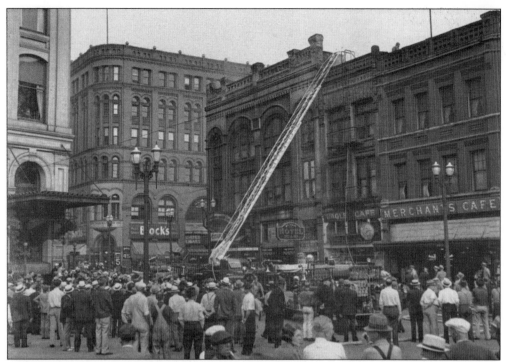

Fire apparatus block Yesler Way between First Avenue and Occidental Avenue South as crews work to control a grease flue fire in the Eagle Café on July 25, 1938. (Courtesy of MOHAI, PI 22886.)

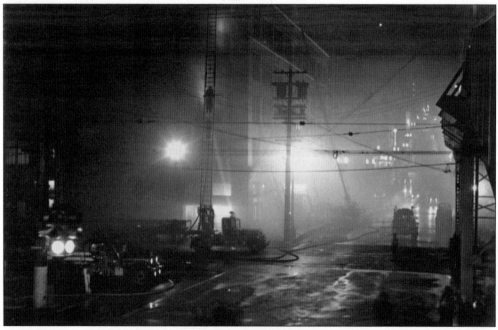

Streetlights and smoke create an eerie scene on Marion Street east of Alaskan Way. It took two hours to control this fire in the Maritime Building during the wee hours of January 24, 1939. (Courtesy of MOHAI, PI 22888.)

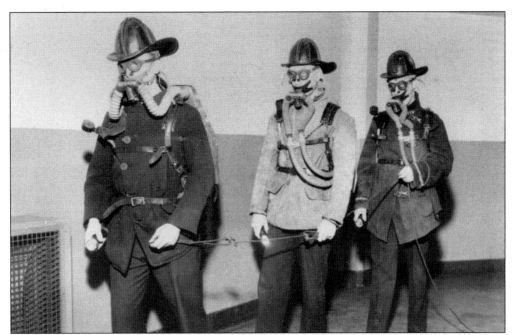

Station No. 10 firefighters demonstrate the use of the smoke masks that were used when respiratory equipment was required. The rope was a lifeline to keep crews from becoming separated when visibility was at zero. Drills like this kept proficiency in the department up. (Courtesy of MOHAI, PI 22795.)

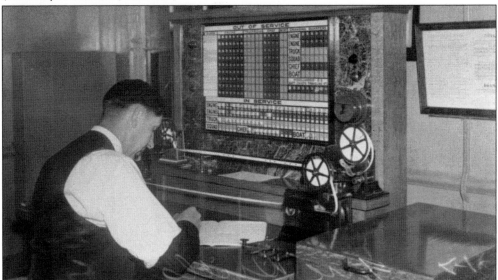

A watch desk, like this one at Station No. 2, was once a fixture in every Seattle firehouse. Signals from the Fire Alarm Center would register the fire-box number on the upper tape. By means of assignment cards (one for each fire box in the city was kept in the wooden cabinet at the right of the desk), the firefighter on watch could determine which units were to respond. By means of wooden pegs on the watch board, the status of the units was known. Once out-of-service units became available again, a coded signal on the lower tape would indicate this. The watchman then returned the pegs to their in-service positions. (Courtesy of MOHAI, PI 22807.)

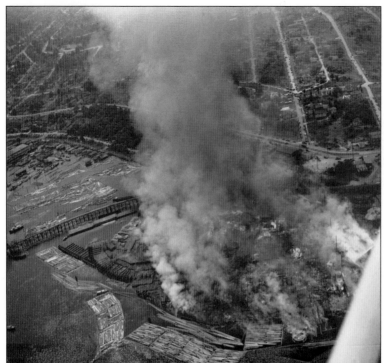

The large, vacant Bolcom-Canal Lumber Company property was the victim of a fire caused by sparks from a cutting torch during its demolition. Smoke from the June 28, 1940, fire drifted south over Queen Anne Hill. (Courtesy of MOHAI, PI 22885.)

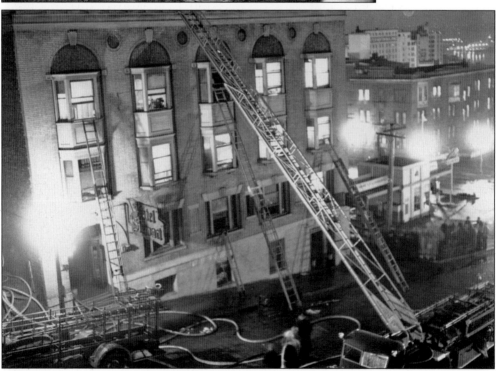

Four occupants died of smoke inhalation when a fire struck the Stewart Hotel at 517 Madison Street shortly after 3:00 a.m. on May 8, 1941. Fifteen occupants were rescued with the fire department's ladders. (Courtesy of MOHAI, PI 22894.)

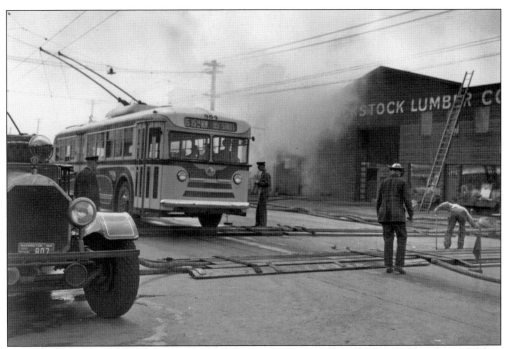

A Seattle Transit trolley bus threads its way over hose as firefighters had to block Elliott Avenue West the morning after this major blaze destroyed the Blackstock Lumber Company. The fire occurred on the evening of August 28, 1941. (Courtesy of MOHAI, PI 22899.)

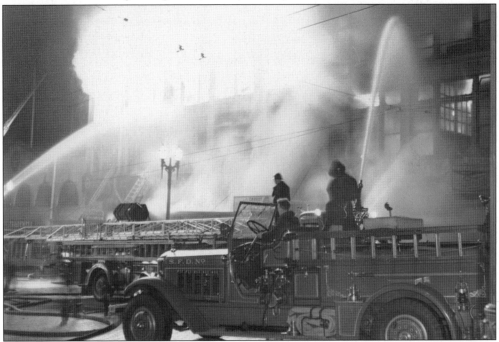

On December 14, 1941, master-hose streams were needed to fight this fire at the Corner Market Building on First Avenue and Pike Street. It took 15 engine companies, 2 hose companies, and 4 ladder companies almost three hours to control the blaze. (Courtesy of MOHAI, PI 22905.)

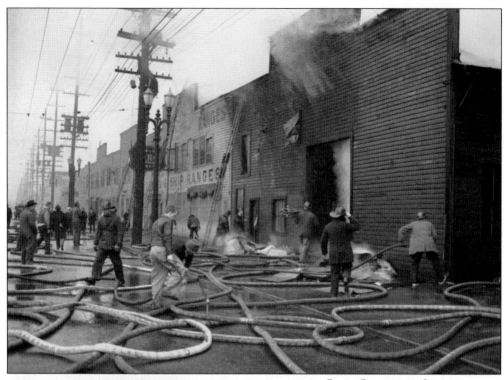

Coast Containers, Inc. was destroyed along with its stock of excelsior and packing material on the morning of March 13, 1942. Hoses filled First Avenue South below Lander Street, shutting down traffic for several hours. (Courtesy of MOHAI, PI 22910.)

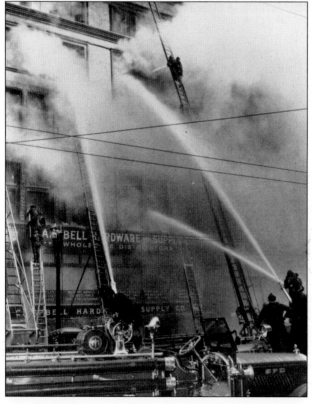

On the afternoon of April, 18, 1942, a fire started on the third floor of Campbell Hardware and Supply Company and spread to the fourth floor before containment. Two firefighters received serious injuries when they were knocked from a ladder. (Courtesy of MOHAI, PI 22912.)

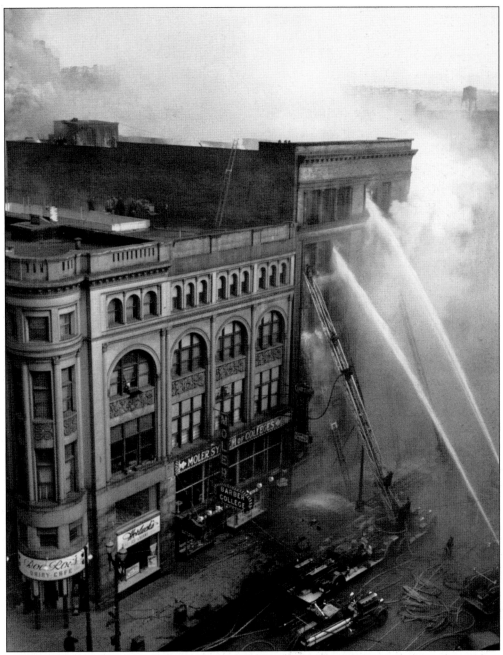

An aerial view shows some of the fire apparatus needed to control the Campbell Hardware blaze at 108 First Avenue South. (Courtesy of MOHAI, PI 22911.)

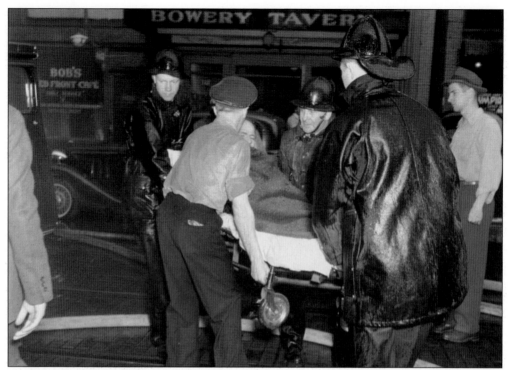

One of the injured firefighters is taken to a waiting ambulance during the Campbell Hardware fire. Two firefighters were injured when they were knocked from a ladder, and two others suffered smoke inhalation. (Courtesy of MOHAI, PI 22913.)

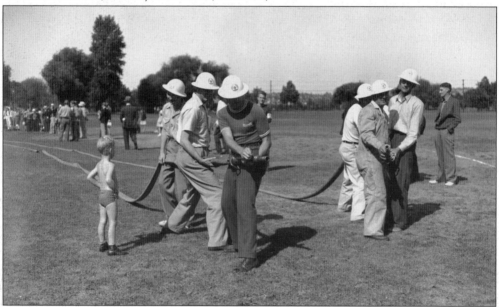

The shortage of manpower during World War II was eased when volunteers from the city joined the Civil Defense Auxiliary. They received fire-department training and, using makeshift hose trucks pulling trailer pumps, were stationed around the city. Here they combine a drill with a family outing in August 1942. (Courtesy of MOHAI, PI 22822.)

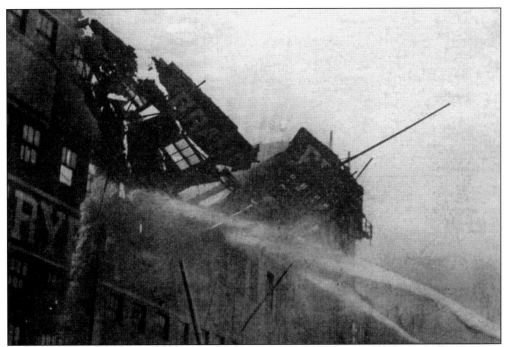

The Frye and Company slaughterhouse and meatpacking plant was destroyed on February 18, 1943, when a Boeing B-29 bomber on a test flight crashed into the building. Here a section of wall collapses as fire raced through the building. (Courtesy of Chief Fitzgerald collection.)

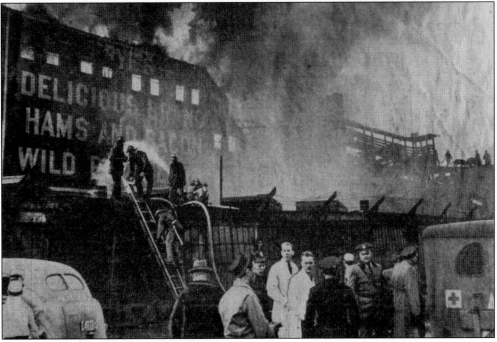

Firefighters became herdsmen as they scrambled to round up escaping pigs at the Frye and Company fire at 2203 Airport Way. The 32 killed in this incident make it the largest life-loss fire in Seattle's history. The dead included firefighter Luther Bonner. (Courtesy of Chief Fitzgerald collection.)

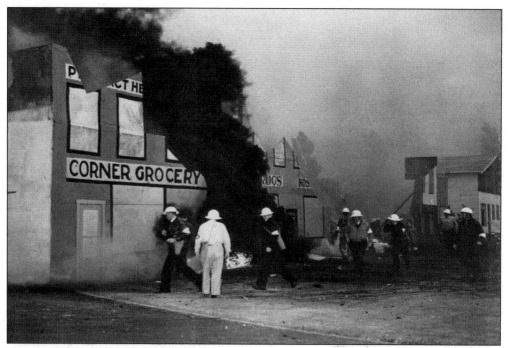

The Civil Defense Auxiliaries staged a show for spectators at the University of Washington's Husky Stadium, which included this mock city neighborhood. This segment of the drill was called "Fire Threatens Corner Grocery." (Courtesy of UW, 26369.)

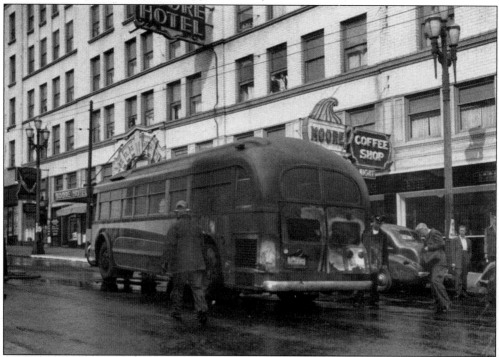

On December 26, 1944, firefighters from Station No. 2 mop up after an engine fire in a Seattle Transit bus on Second Avenue south of Virginia Street. (Courtesy of MOHAI, PI 22932.)

Six

POSTWAR GROWTH

After the acquisition of surplus radios, the fire department entered the "wireless" age. With the radios, fire companies were able to conduct inspections of buildings within their districts while remaining available for response. On March 12, 1946, a ballot measure sponsored by Seattle Local 27 was passed lowering the work week for firefighters to 48 hours. It took effect on January 1, 1947, and resulted in the closing of one engine company and one truck company. Also, the crew of the second fireboat was reduced to two.

New fire apparatus began to arrive—six pumpers in 1946, nine pumpers in 1949, and six city-service ladder trucks and one pumper in 1950. A final ladder truck was placed in service in 1951. The 1950 Census showed Seattle had 467,591 residents. In January 1954, the northern city limits were moved all the way to 145th Street, and the large area that had been covered by three King County fire districts then became part of the Seattle Fire Department.

On the evening of May 20, 1958, the largest fire since 1889 destroyed three blocks of lumber stored in the yard at Seattle Cedar Lumber and Manufacturing, located at 4735 Shilshole Avenue in Ballard. Six drying kilns were also destroyed, and the fire burned toward the Ballard Bridge, destroying buildings on the property of several other businesses. Also in 1958, a major change in emergency medical care took place. The delivery of six Ford "Ranch Wagon" station wagons equipped with stretchers gave firefighters the ability to transport critical patients without waiting for a private ambulance.

Claude Harris, the first African American firefighter, was appointed in January 1959. Seattle's population stood at 557,087 by 1960. On April 14, 1961, the Seattle Fire Department placed the first jet-powered ladder truck in the United States into service. However, the Allison-Boeing turbine engine proved unsuccessful on the city's hills, and the motor was replaced with a Hall-Scott gasoline model in 1962.

In 1963, Chief Fitzgerald retired after serving the department for 52 years, over 25 of them as its chief. Battalion chief Gordon Vickery was then promoted to the position of chief. He made some changes in the department's appearance with a new uniform style and apparatus markings. However, by 1970, however, the paramedic program would significantly alter emergency medical care and change the character of the fire service.

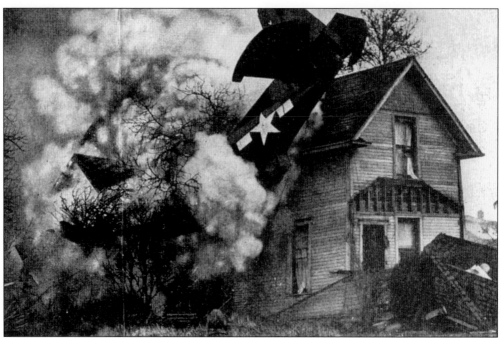

En route from Sand Point Naval Air Station to Tillamook, Oregon, on February 9, 1946, a navy torpedo bomber hit this house at 1206 Cloverdale Street in the South Park neighborhood when its engine suddenly died. The pilot attempted to glide to the street, but the plane hit some power lines and veered into the house. Luckily, the pilot received only minor injuries, and the two older women who lived there were unhurt. (Courtesy of Chief Fitzgerald collection.)

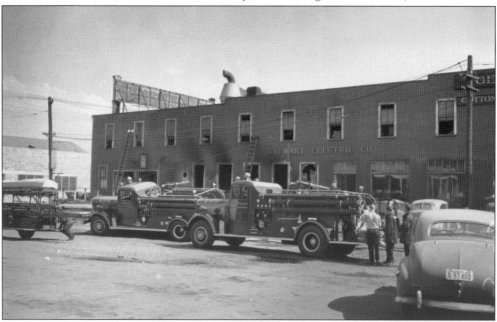

Two of the six new Kenworth pumpers were at this August 1946 Stewart Electric fire. Kenworth became the primary source for Seattle's fire apparatus in the 1940s and remained so into the 1970s. (Courtesy of MOHAI, PI 22943.)

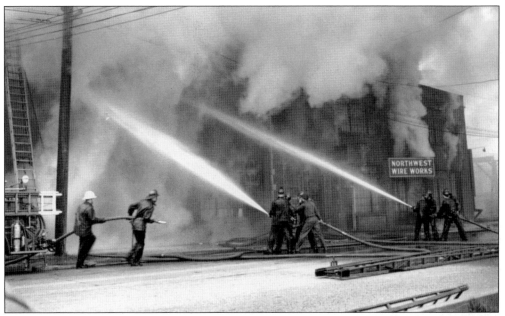

Pictured here on the afternoon of March 6, 1947, hose crews battle a three-alarm fire at the Union Paper Box Company, located at 1255–1259 Westlake Avenue North. The fire started in a portion of the first floor used by the Northwest Wire Works. Three firefighters were temporarily trapped on the first floor by a flashover but managed to follow their hose line back to safety. (Courtesy of MOHAI, PI 22947.)

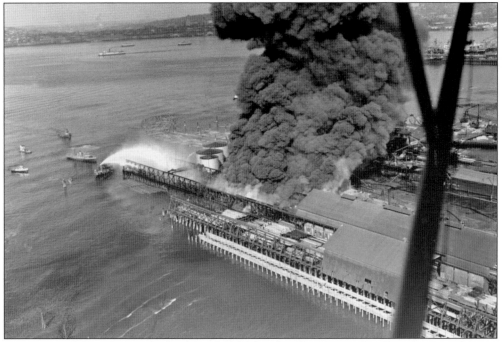

Creosote-soaked timber resulted in a smoky blaze at the West Coast Wood Preservative plant on the afternoon of March 28, 1947. The explosions that occurred during the fire were caused by drums of creosote. (Courtesy of MOHAI, PI 22950.)

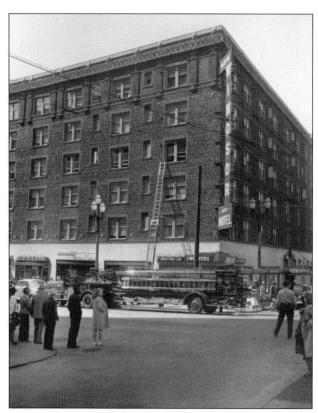

Firefighters make short work of a mattress fire on the fourth floor of the Windsor Hotel at Sixth Avenue and Union Street on May 5, 1947. (Courtesy of MOHAI, PI 22953.)

Shortly after 9:00 a.m. on August 16, 1947, summer school students were quickly evacuated when fire started in the Sigma Chi fraternity house on Eighteenth Avenue Northeast and East Forty-fifth Street. (Courtesy of MOHAI, PI 22954.)

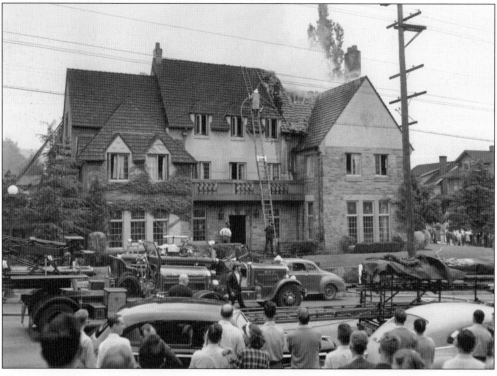

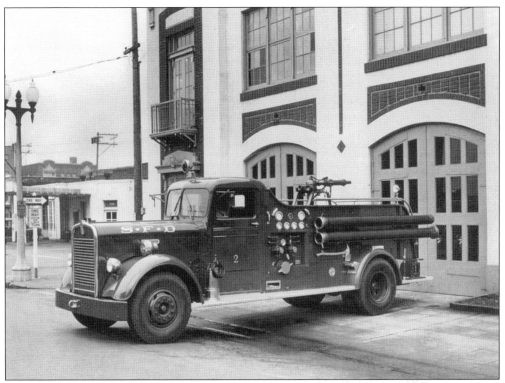

Engine No. 2's 1949 Kenworth 1,500-gallon-per-minute pumper is a typical example of Seattle's immediate postwar fire-truck deliveries. (Courtesy of Jim Stevenson collection.)

Engine No. 15's 1920 Seagrave pumper, which required replacement by 1946, is a typical example of the older fire apparatus. (Courtesy of Betty Stanton.)

The very old and the very new were represented in Seattle's 1949 Fourth of July parade. A horse-drawn steamer and a recently delivered Kenworth pumper are headed north on Third Avenue at Pike Street. (Courtesy of Local 27.)

On September 25, 1949, firefighters load the last of Station No. 20's trappings into the supply truck. The company, originally located on Gilman Avenue, had begun moving to its new quarters on Thirteenth Avenue West four days earlier. (Courtesy of MOHAI, PI 22762.)

Smoke billows from all four floors of the Globe Electric Company at 307 First Avenue South on the afternoon of January 6, 1951. Three firefighters suffered injuries battling this blaze. (Courtesy of SFD.)

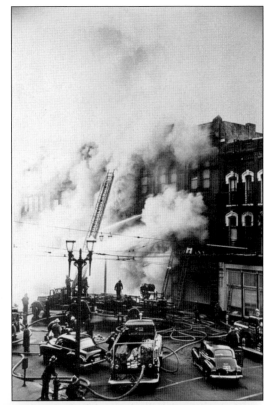

Hank Spadoni and Henry Berntzen, two of the firefighters injured at the Globe Electric fire, catch their breath while waiting for oxygen. They had been trapped in a draft of heat and smoke on the first floor when the ceiling collapsed. (Photograph by Ray Kirlin; courtesy of Local 27.)

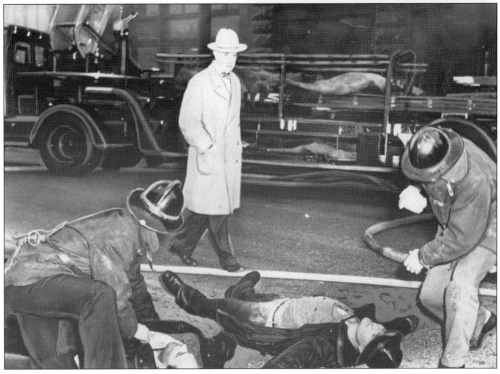

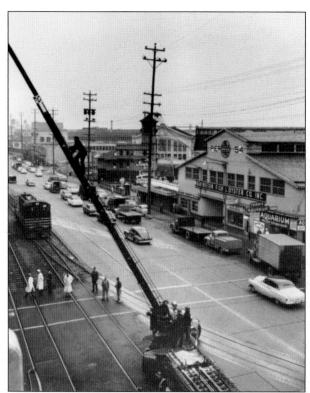

Ladder No. 4 raised its aerial to the top level of the Alaskan Way Viaduct shortly after its completion in the early 1950s to show that the viaduct was accessible from the street level. This test was conducted at Spring Street with the fireboat's Station No. 5, the third such building on the same site, visible with its hose-drying tower in the background, just beyond Ivar's Fish Bar. (Courtesy of MOHAI, PI 22840.)

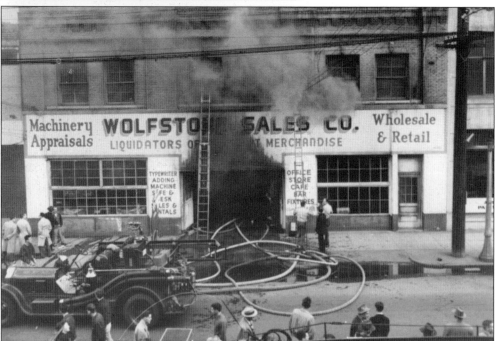

Wolfstone Sales was hit by a fire on the afternoon of March 10, 1953. The building was a warehouse for the liquidation of bankrupt merchandise, and its contents generated plenty of smoke. The fire began when a solvent that was being heated boiled over. (Courtesy of MOHAI, PI 22976.)

Firefighters from Station No. 31 pose in 1954 with Engine No. 31 and Ladder No. 5. The station, formerly part of King County Fire District 8, was annexed into Seattle in January of that same year. (Courtesy of Local 27.)

Pictured here on March 3, 1955, firefighters extinguish the hot spots in what remains of a Fairview Avenue houseboat on Lake Union. (Courtesy of MOHAI, PI 22982.)

The firefighters' union, Local 27, participated in a trade fair sponsored by the King County Labor Council during the 1950s. The local's booth included a functional mock-up of a fire-station watch desk along with other tools of the trade. (Courtesy of Local 27.)

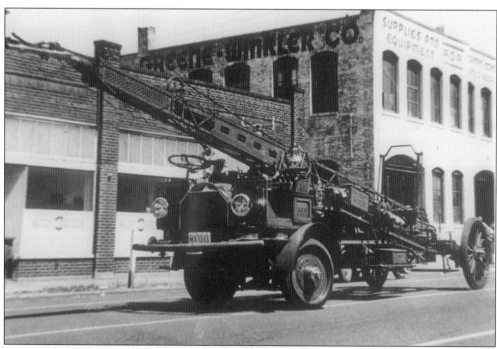

The old 1904 Champion water tower, motorized since 1916, was finally cut up for scrap in 1955. Pictured here outside Station No. 2, it spent its final years in storage. (Courtesy of LRFD.)

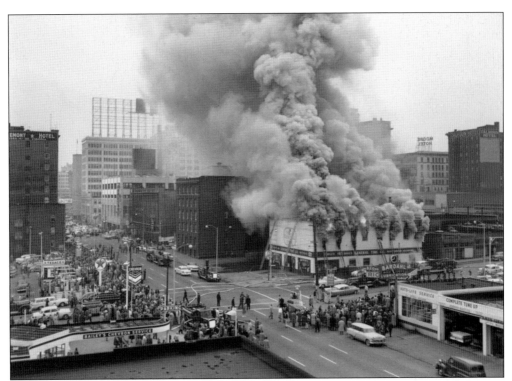

Thick smoke fills the air on Fourth Avenue at Lenora Street shortly after noon on November 21, 1957, when fire struck the General Tire Company. Four firefighters suffered injuries at this blaze, which started when sparks from a faulty electric switch ignited retreading material. The medical bag belonging to Dr. Maxson, the fire department's physician, was stolen when he stepped away to examine an injured fireman. (Courtesy of MOHAI, PI 22988.)

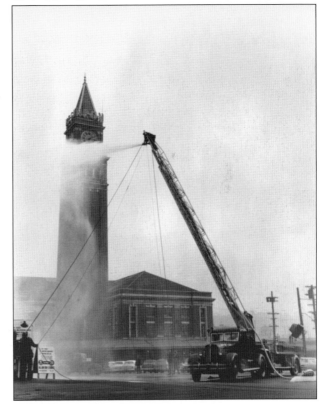

Ladder Truck No. 1 crew members operated their aerial-ladder pipe during a drill in early 1958 on Jackson Street, east of Second Avenue South and west of the King Street Railroad Station. (Photograph by Frank Skidmore; courtesy of Local 27.)

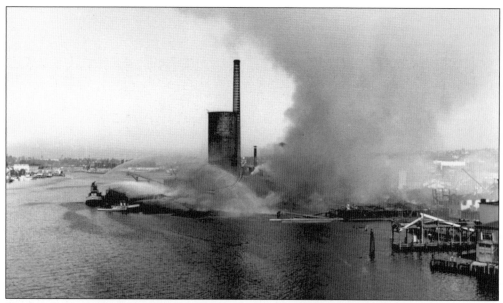

On the morning of May 21, 1958, the fireboat *Duwamish*, along with the crews of many land-based fire companies, soak the remains of the Seattle Cedar Lumber Company's block-long storage area. The fire the previous evening was the most extensive in Seattle since the great fire of 1889. This photograph, taken from the Ballard Bridge, would not have been possible during the height of the fire. The bridge was closed when its paint started to blister in the heat. (Courtesy of MOHAI, PI 22991.)

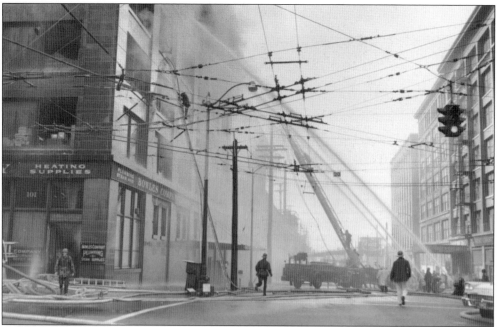

Seattle police shut down the intersection of First Avenue South and Jackson Street when fire gutted the Bowles Plumbing and Heating Company. The fire, which occurred shortly after 8:00 a.m. on August 17, 1958, was one of seven arson fires set in the area over the weekend. (Courtesy of MOHAI, PI 22993.)

Fire crews secure the remains of the New Hollywood Hotel at First Avenue and Stewart Street. Two occupants were killed in this arson fire, which began shortly after 2:00 a.m. on August 26, 1958. (Courtesy of MOHAI, PI 22994.)

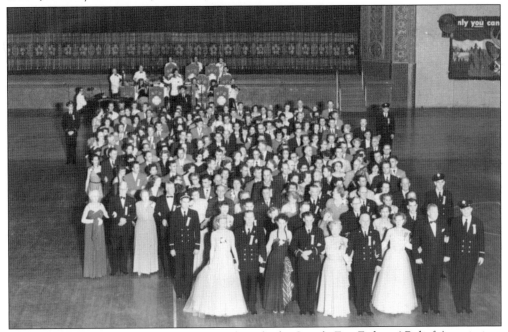

The Firemen's Ball was an annual event to benefit the Seattle Fire Fighters' Relief Association, which was formed after the death of Herman Larson, the first Seattle firefighter killed in line of duty. The association supported firefighters and their families in times of trouble. (Courtesy of Local 27.)

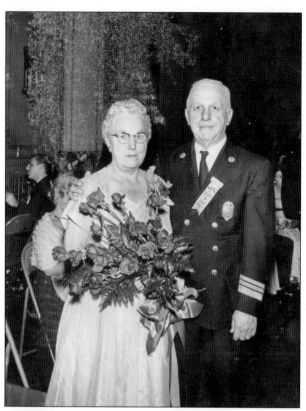

Chief William Fitzgerald poses with his wife at the 1959 Firemen's Ball. (Courtesy of Local 27.)

Seattle was the recipient of one of two fire trucks manufactured with the experimental Allison-Boeing gas-turbine engine. Here the ladder truck, dubbed the "Turbo Chief" by the manufacturer, is posed on the top deck of the Alaskan Way Viaduct near Madison Street. The jet engine was replaced by a Hall-Scott gasoline engine after the experiment proved less than successful. (Courtesy of Local 27.)

A fire on the second floor of the Colman Ferry Terminal at Pier 52 on the night of February 6, 1961, spread into the cockloft above the Pacific Fish Company and the Ferry Dock Tavern on the ground floor. Those businesses were damaged as firefighters pulled down sections of the ceilings to extinguish the hidden fire. (Courtesy of MOHAI, PI 22995.)

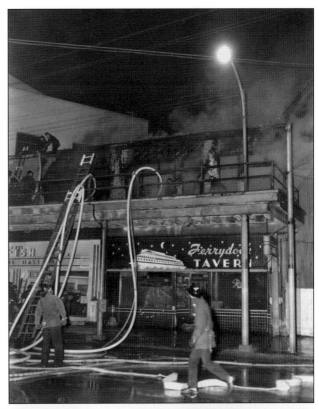

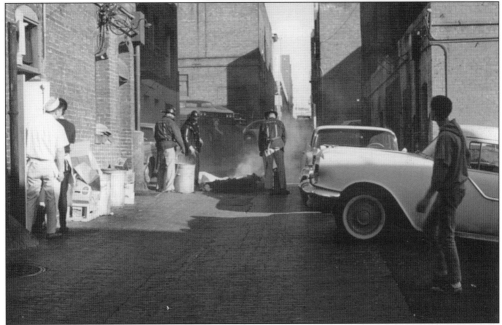

A routine mattress fire was extinguished in the alley behind the 1400 block of Seventh Avenue on an afternoon in July 1966. The chef and a kitchen aide from Canton Garden Restaurant observe the proceedings from the back door. (Courtesy author.)

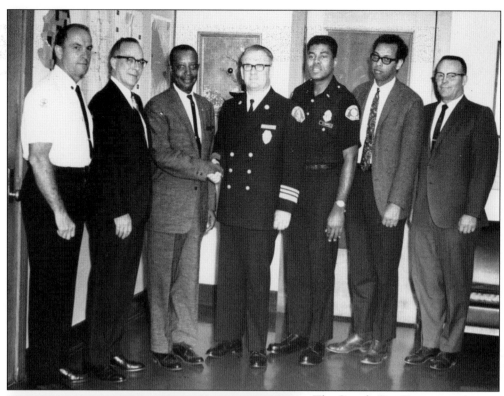

The Seattle Fire Department's Trainee Program was part of a citywide measure to aid minority candidates to be successful in the examination process. Claude Harris, Seattle's first African American firefighter, was promoted to lieutenant in 1968. Standing here next to Chief Vickery, he is with the group that initiated the program for the fire department. (Courtesy of SFD.)

A small boy was rescued from the top floor of a burning house in the late 1960s. (Courtesy of Local 27.)

Seven

PARAMEDICS AND "HAZ-MAT"

Seattle's population was 530,831 in 1970, the year Medic One was placed in service, and 19 firefighters took part in this first step of the paramedic program. Twenty persons were killed in the tragic Ozark Hotel fire during the early morning hours of March 20, 1970. The fire, which started in the lobby, had spread up through the stairways and all the halls before the arrival of the first fire units. This fire and the Seventh Avenue Apartments fire, where 12 occupants died a year later, resulted in the passage of stricter fire ordinances for residential occupancies.

After Chief Vickery's retirement in 1972, Jack Richards was appointed chief. In December 1974, Mayor Wes Uhlman replaced him with Glenn Shelton, but Chief Shelton was soon diagnosed with cancer and died the next month. Former assistant chief Hanson was called out of retirement to be appointed chief on February 7, 1975. In 1977, during his administration, Bonnie Beers, Seattle's first female firefighter, was appointed. Chief Hanson retired for the second time on December 31, 1979.

Mayor Charles Royer picked Robert Swartout, the chief of training, to be chief beginning January 1, 1980. That year saw Seattle with a population of 493,846. It also saw the fire department upgrade procedures for incidents involving dangerous chemicals with the installation of a hazardous-materials unit at headquarters. This unit is dispatched to all alarms involving hazardous substances, including fires, leaks, spills, and even suspected drug labs.

Chief Swartout left the Seattle Fire Department to accept the fire-chief position in Houston in December 1984. Mayor Royer chose Claude Harris, the first African American firefighter, as the new chief. The 1990 Census gave Seattle a population of 516,259 people.

Seattle suffered its greatest loss of firefighters at a single incident on the evening of January 5, 1995, when Lt. Walter Kilgore, Lt. Gregory Shoemaker, firefighter James Brown, and firefighter Randall Terlicker fell into the basement as the floor collapsed at Mary Pang Food Products on 811 Seventh Avenue South. The stepson of the owners was later convicted of setting the blaze.

When Chief Harris retired at the end of 1996, he was replaced by James Sewell, former chief of the Ventura County Fire Department and the first chief picked from outside the city since Frank Stetson in 1911.

Three Kenworth pumpers, all different ages, team up to fight a fire in a barrel-restoration plant. Engine No. 36, left, is from 1964. In the center is Engine No. 27, with a large 1967 pumper equipped with a Fire Boss dry-chemical system. Hooked to the hydrant beneath the old First Avenue South Bridge on the right is Engine No. 26's 1954 Kenworth pumper. (Courtesy author.)

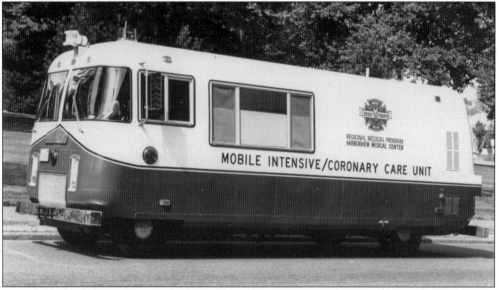

The Medic program was started in 1969 after a meeting between fire chief Gordon Vickery and Dr. Leonard Cobb of King County Hospital's Harborview Medical Center concerning the use of firefighters to provide out-of-hospital coronary care. On March 7, 1970, the program began operation using this Tiarra motor home on an Oldsmobile Toronado chassis. Trained initially only in coronary care, the first 19 firefighters became full paramedics the following year. Before 1970 ended, this vehicle was replaced by a more practical van with a raised camper top. (Photograph by Ray Kirlin; courtesy of SFD.)

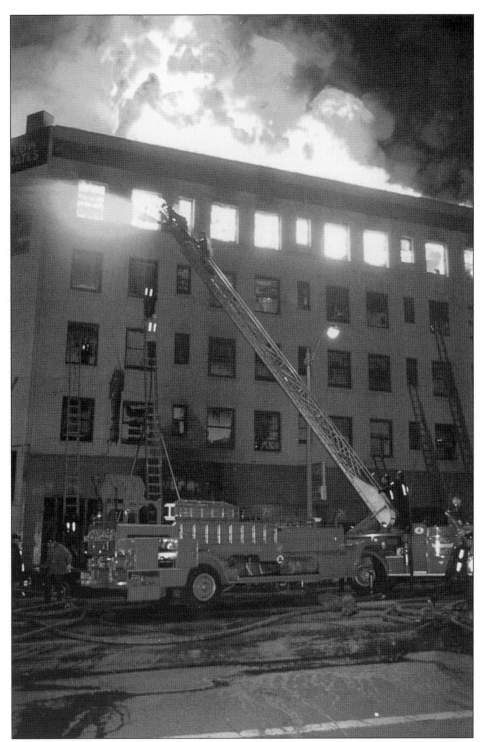

Shortly after 2:30 a.m. on March 20, 1970, an arson fire struck the Ozark Hotel on Westlake Avenue, killing 20 residents and injuring 15 more. Here a hose stream is directed into the top floor from Ladder No. 4's aerial. (Courtesy author.)

Ladder No. 4's crew remove an injured upper-floor resident of the Ozark Hotel during the early stages of operation. The fire was controlled in just under an hour following a three-alarm response as well as calls for two more engines and another ladder truck. (Courtesy of UW; Don Wallen collection, 3/20/70.)

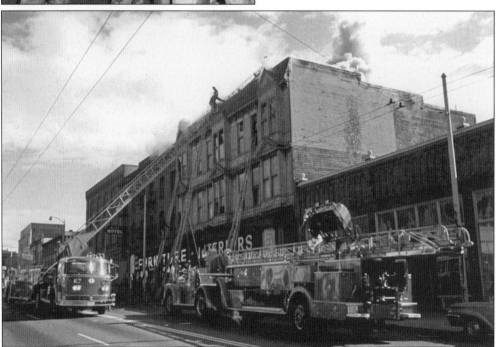

It was Easter Sunday afternoon, March 29, 1970, when a fire struck the vacant Twins Hotel on First Avenue near Lenora Street. (Courtesy author.)

Mayor Wes Uhlman, with fire chief Gordon Vickery, installs a "Host" sign on Fire Station No. 5. The Host Program of the Seattle Convention and Visitors Bureau provided tourist information and literature to public buildings in prominent neighborhoods. (Courtesy of UW; Don Wallen collection, 6/3/70.)

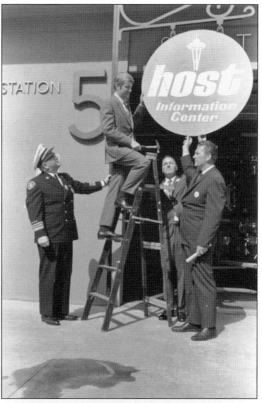

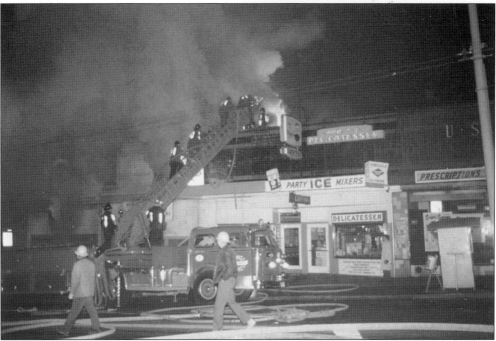

Pictured here in the wee hours of June 12, 1970, firefighters take a hose line to the roof of a commercial-apartment building on First Avenue near Pine Street. (Courtesy author.)

Chief Vickery, front right, poses with a class of graduating recruits in 1971. Behind him is deputy chief of training Russell Jacobson. Owen Pletan, captain of recruits, is one step up on the far left. (Photograph by Ray Kirlin; courtesy of SFD.)

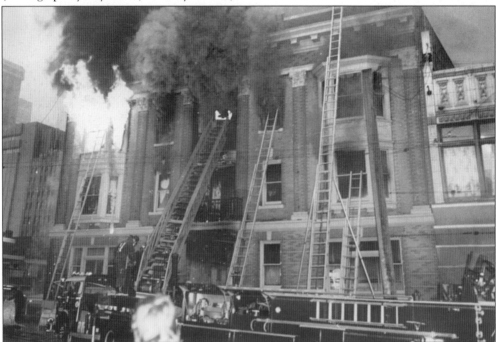

Twelve occupants were killed and eight were injured when a fire struck the Seventh Avenue Apartments shortly before 6:00 a.m. on April 25, 1971. (Courtesy of SFD.)

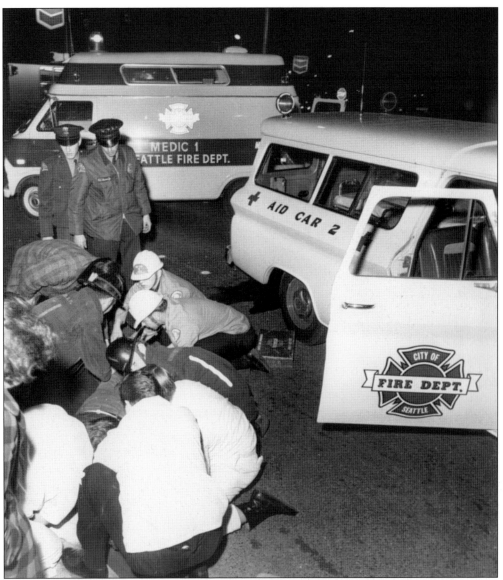

Firefighters from Station No. 2 and paramedics treat the victim of a traffic accident in the early 1970s. The Ford van, with the raised camper top, replaced the original Medic One vehicle in October 1970. (Photograph by the *Seattle Times*; courtesy of Local 27.)

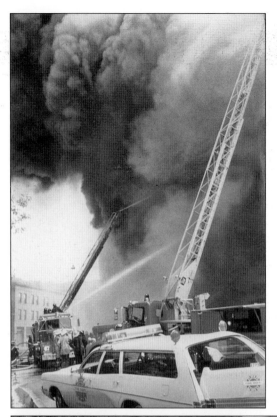

A large commercial-industrial building used by Ace Novelty Company was gutted from the third floor to the roof by an arson fire on June 14, 1974. Sixteen firefighters suffered injuries and heat exhaustion during the long operation. (Courtesy author.)

Firefighters struggle to control a burst section of hose during the long battle to beat the flames at Ace Novelty. The fire, at Western Avenue and Columbia Street, took four and a half hours to control. (Photograph by Mike Heaton; courtesy of Local 27.)

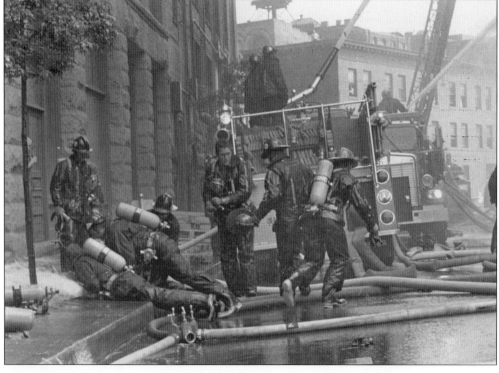

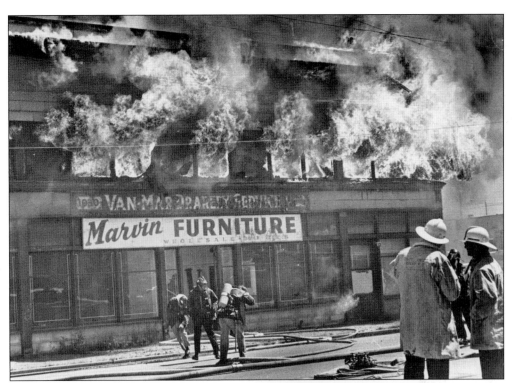

A firefighter dodges falling glass when a fire in the Marvin Furniture Company burst from the upper floor. The fire, which took place on July 25, 1974, destroyed two buildings on First Avenue South across from the site of the Kingdome, then under construction. (Photograph by Denis Law; courtesy of Local 27.)

Capt. Robert Averson tests the sliding pole at the new Station No. 31 on November 10, 1975. (Courtesy of UW; Don Wallen collection, 11/10/75.)

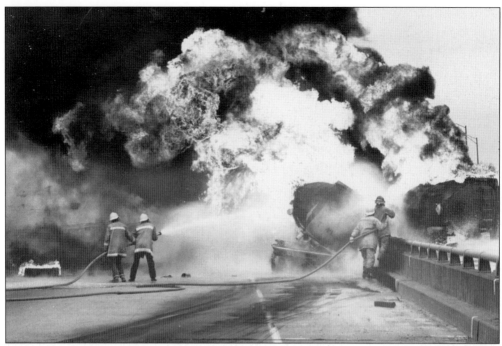

Heat damaged the roadway after a fire involving a gasoline tanker on February 23, 1977. The fire started when the rear tank trailer was struck by an automobile, shoving it against the guard rail of Interstate 90 heading out of town. (Courtesy of Local 27.)

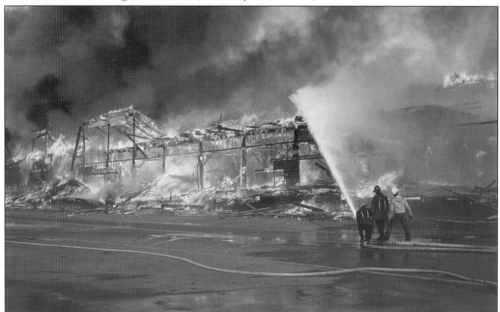

On the afternoon following the gasoline-tanker fire, a spectacular blaze finished off a large, vacant cold-storage warehouse on the property of the Puget Sound Naval Supply Depot, which had recently been deactivated. The building, which was under demolition, was ignited by sparks from a cutting torch. Fortunately the brisk wind that day was out of the north and carried embers out over Elliott Bay. (Courtesy author.)

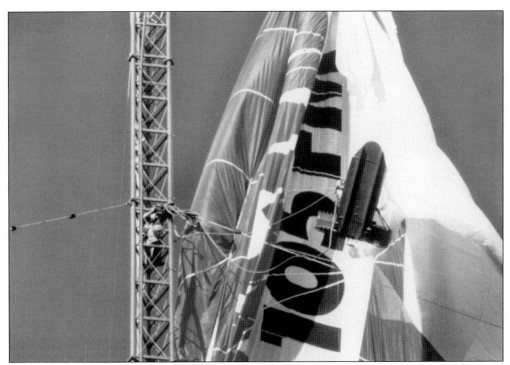

Firefighters from Station No. 31 needed special equipment to rescue a stranded balloonist who had become hung up in the support wires of a radio-transmission tower. (Courtesy of Local 27.)

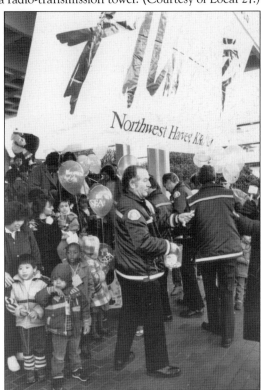

Firefighters lend their support during a drive for food and funds by Northwest Harvest, a local assistance program for families in need. (Courtesy of Local 27.)

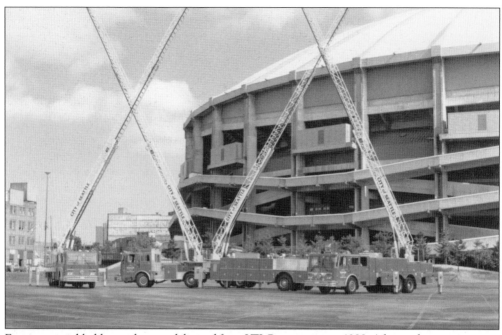

Four new aerial-ladder trucks were delivered from LTI Corporation in 1988. After undergoing rigorous testing, they were displayed in the Kingdome's south parking lot. (Courtesy of Local 27.)

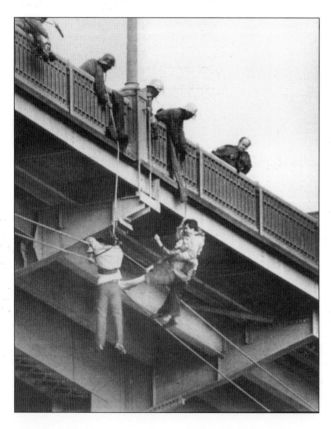

Firefighters Albert Smalls (left) and Tom Erickson rescue a woman trapped on wires beneath the Aurora Bridge on October 13, 1984. (*Seattle Times* photograph by Richard Heyza; courtesy of SFD.)

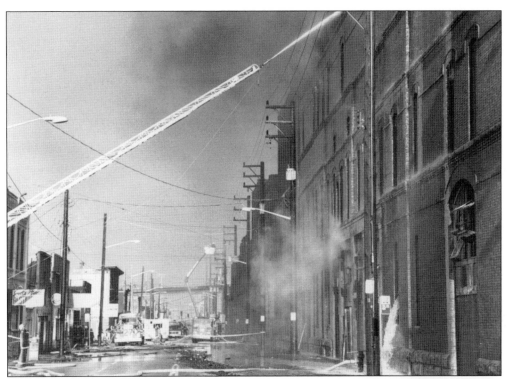

Airport Way remained closed by hose and apparatus the morning of November 14, 1988, after a major fire the night before destroyed a large section of the Rainier Cold Storage and Ice Company. (Courtesy of Local 27.)

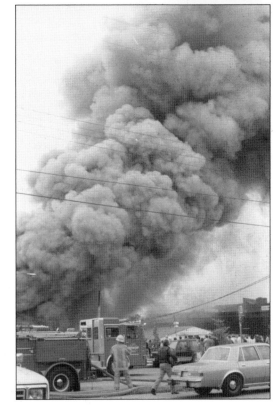

On the evening of May 26, 1987, smoke rolls from beneath the pier as a fire destroyed Ray's Boat House. The popular seafood restaurant on Shilshole Bay was rebuilt after the fire, which started when electrical wiring beneath the pier shorted out. (Courtesy of SFD.)

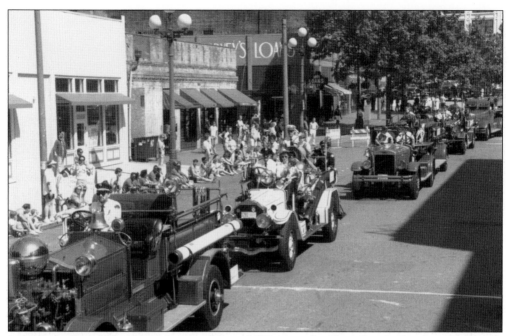

In 1989, the Seattle Fire Department celebrated 100 years of paid, professional service to the city. The festivities kicked off in June with a parade of fire trucks, both old and new. Here a portion of the Last Resort Fire Department's collection passes on Second Avenue South at South Washington Street. (Courtesy of Local 27.)

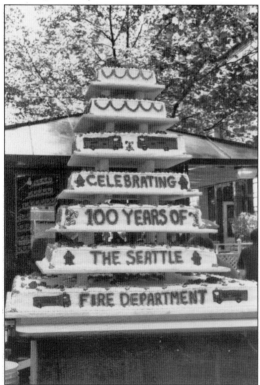

The fire department's huge birthday cake is on display in Occidental Park. (Courtesy of Local 27.)

Three firefighters suffered injuries during this three-alarm blaze, which destroyed a six-unit apartment building at 1403 Northeast Sixty-sixth Street in the early evening of August 2, 1990. (Photograph by Greg Bennett; courtesy of Local 27.)

Understandably emergency medical care improved after the inception of paramedic service. Here the victim of an automobile-pedestrian accident receives care from firefighters and paramedics. (Courtesy of Local 27.)

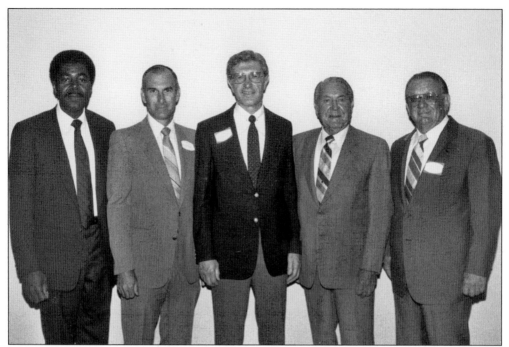

Four of the department's former leaders join Chief Claude Harris for a group photograph. From the left to right, they are Chief Harris, Bob Swartout, Jack Richards, Frank Hanson, and Gordon Vickery. (Courtesy of Chief Harris collection.)

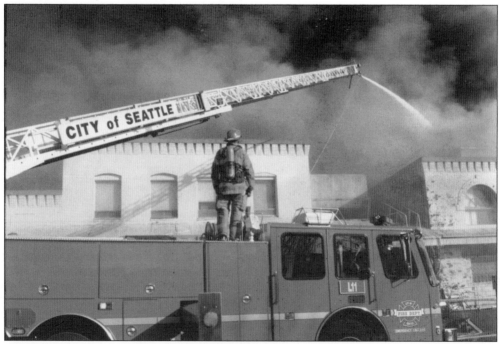

Water is poured into the burning vacant section of the former Sunny Jim peanut-butter factory on Airport Way South at South Adams Street. The fire, started on the afternoon of February 20, 1997, was caused by a hand torch during a roof-repair operation. (Courtesy of Local 27.)

Eight

MARITIME FIREFIGHTING

Since its earliest days, the city's waterside location has been a major factor in its economy. The Port of Seattle has been one of the key harbors on the West Coast since the late 1800s and continues in that role. Naturally fires connected to the waterfront have been a major concern of the fire department. During the first year of the paid department, a fireboat was ordered and built. The *Snoqualmie* was the first purposely built fireboat on the Pacific coast, entering service in early 1891. Since then, fireboats *Duwamish*, *Alki*, and *Chief Seattle* have all made their contributions to the protection of the city. In 2007, a new fireboat, the *Leschi*, will begin its service.

During the 1970s, several Seattle Fire Department members received special marine emergency training with funding secured by Capt. Bobby Lee Hansen from the United States Maritime Administration. The funding ran out, but the expertise learned was passed down to a new generation of firefighters. The heart of the Marine Division is a marine-fire apparatus. Designated "Unit 99," it is equipped with all the specialized tools required for shipboard emergencies.

The fireboats, as well as the many ship and pier fires, have added a colorful and sometimes unusual tone to Seattle's fire history.

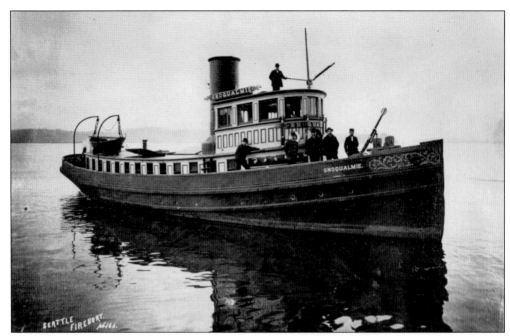

The fireboat *Snoqualmie* was built during 1890 by the Seattle Shipbuilding and Dry Dock Company. It entered service as Engine No. 5 on January 5, 1891, and was the first vessel on the Pacific coast specifically built as a fireboat. San Francisco's *Governor Irwin*, though in service dating back to 1880, was actually a converted tugboat. (Courtesy of MOHAI, 5597.)

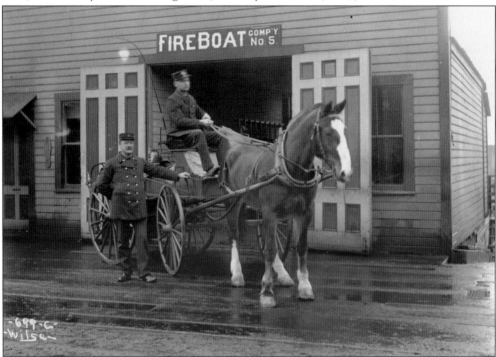

Engine No. 5 needed its hose wagon, and for the first few years, this one-horse hose cart ran as Hose No. 5 along with the fireboat. (Courtesy of MOHAI, 88.33.80.)

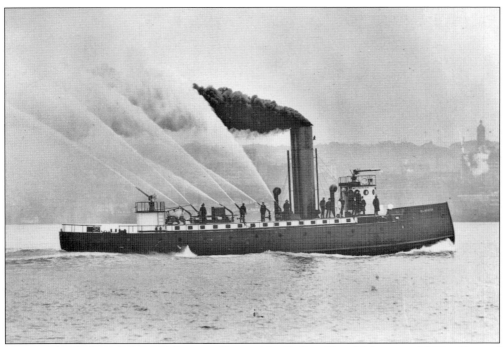

In 1910, the fireboat *Duwamish* became Engine No. 5. Capable of delivering 9,000 gallons of water per minute, it is seen here showing off its abilities on the Seattle waterfront. (Courtesy of MOHAI, 210.)

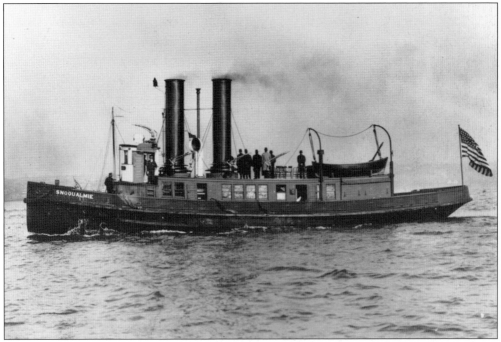

After the *Duwamish* entered service, the older *Snoqualmie* was rebuilt. Converted to burning oil, its pumping capacity was somewhat reduced from 7,000 to 6,000 gallons per minute. After rebuilding, it became Engine No. 31, a second fireboat. (Courtesy of MOHAI, 212.)

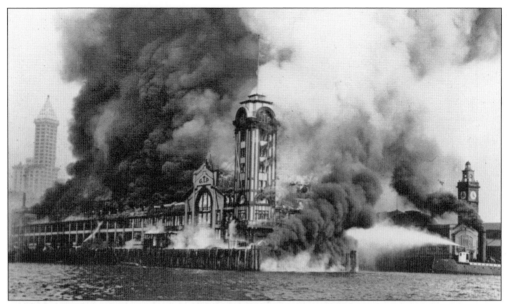

The afternoon of July 30, 1914, was dubbed by one Seattle newspaper as "the day the air turned to fire," after a flashover trapped two firefighters along with Hose No. 5's wagon behind a wall of flame at the Grand Trunk–Pacific Railroad dock next door to Fireboat No. 5's station. Badly burned, both managed to escape off the pier into the bay. Firefighter Patrick Cooper died three days later, and firefighter John Stokes had to retire due to his injuries. (Courtesy of UW; A. Curtis, 38925.)

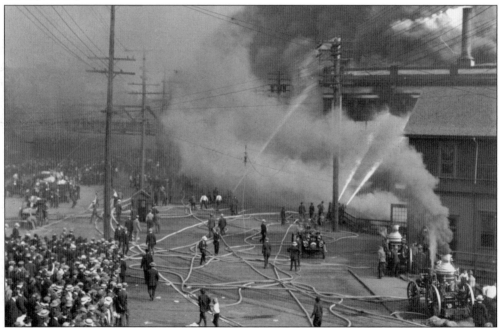

Firefighters pour water from street level on the burning Grand Trunk–Pacific dock, as seen from a footbridge over the waterfront one pier north. The building on the right just behind the two steamers is Fireboat Station No. 5. (Courtesy of MOHAI and Puget Sound Maritime Historical Society 5011-12.)

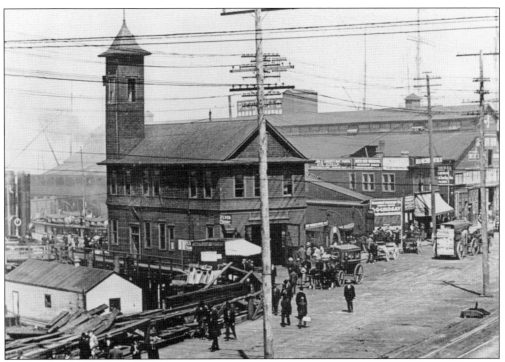

The twin stacks of the *Duwamish* can be seen at the far left behind Fire Station No. 5 as the waterfront around it bustles with activity about 1912. (Courtesy of MOHAI, 2781.)

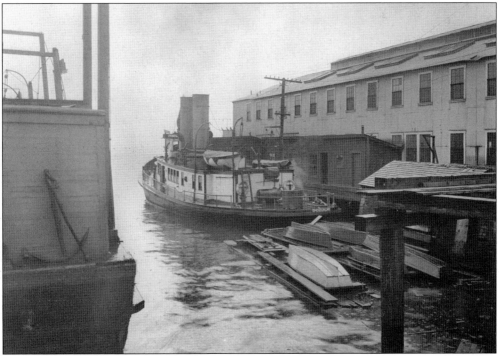

For a number of years, the *Snoqualmie*, as Engine No. 31, was quartered in a wooden shack on the end of a pier at the foot of Massachusetts Street. (Courtesy of Seattle City Archives, 5821.)

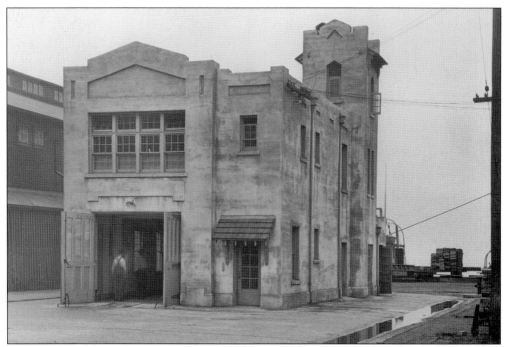

In 1920, this permanent fire station was built at the foot of Massachusetts Street for the second fireboat. For a long time after the boat was relocated elsewhere, this station housed Engine Company No. 19. It closed in 1967. (Courtesy of Seattle City Archives, 2704.)

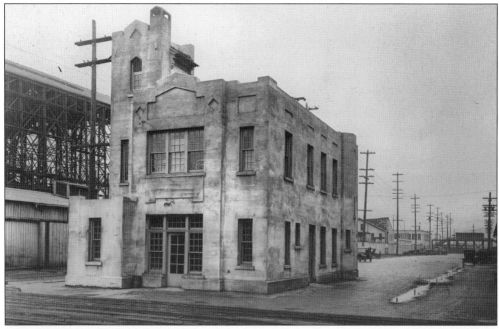

This is the 1920 Fireboat Station No. 31 as viewed from the pier behind it. The long, dead-end block of Massachusetts Street coming west from East Marginal Way is quite evident. The framework structure on the left is part of the Seattle Shipbuilding and Dry Dock Company. (Courtesy Seattle City Archives, 2703.)

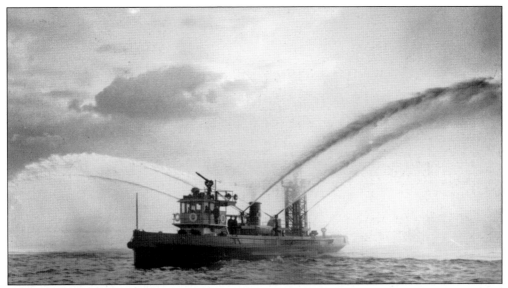

The Pacific Coast Engineering Company of Oakland built the fireboat *Alki* in 1927. It entered service as Engine No. 5 (Boat No. 1) on December 10, 1928, and the *Duwamish* was moved to Engine No. 31 (Boat No. 2). The old *Snoqualmie* was moved onto Lake Union and placed in service as Engine No. 39, or Boat No. 3, until the Depression forced its disbanding on September 25, 1935. The *Alki*, minus its rear-elevating tower monitor, is still in service as Seattle's second fireboat. Now called Engine No. 3 and quartered at Salmon Bay Fishermen's Terminal, it is due to be replaced next year. (Courtesy of MOHAI, PI 22765.)

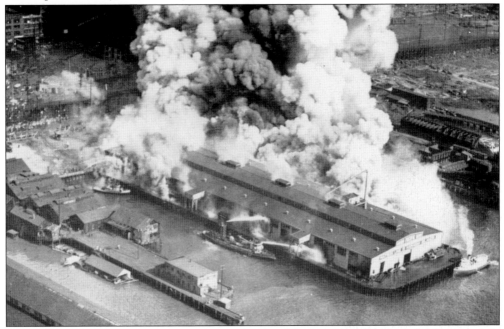

The fireboat *Alki* is pictured here on the north side of the Union Pacific Railroad Dock on July 17, 1929, when a major fire heavily damaged the pier. The fire ignited the bridge of the Matson Lines freighter *Mauna Ala*, but that fire was quickly extinguished as the ship was towed to safety. Eight firefighters suffered injuries here, one seriously. (Courtesy of MOHAI, 8582.)

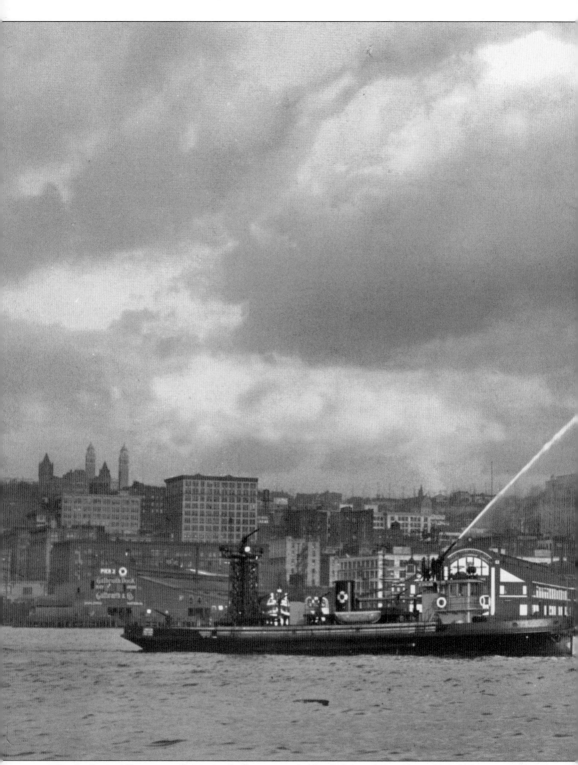

The fireboat *Alki* is seen during a drill against the backdrop of Seattle's 1929 skyline, with the 1913-built, 42-story Smith Tower as its high point. The reconstructed Grand Trunk–Pacific dock

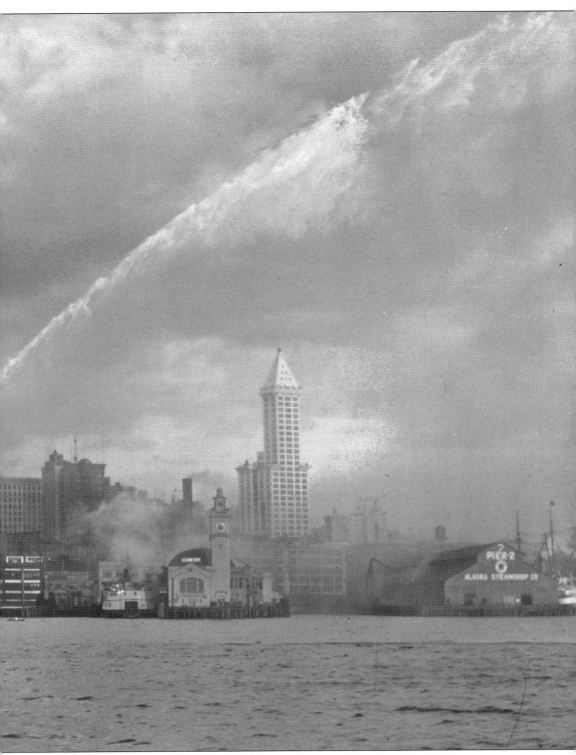

is visible directly behind the *Alki's* wheelhouse. (Courtesy of MOHAI, PI 22768.)

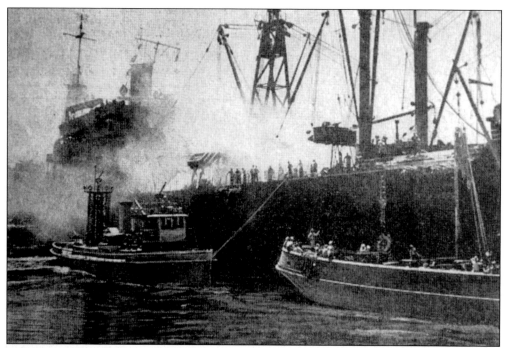

Fire damaged a U.S. Navy assault transport tied up at Pier 88 shortly before 11:00 a.m. on June 17, 1945. The fire was fought by firefighters from Seattle, the U.S. Navy, and the U.S. Coast Guard. (Courtesy of Chief Fitzgerald collection.)

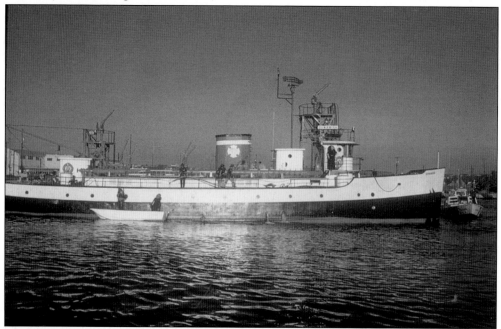

In 1949, the fireboat *Duwamish* was heavily rebuilt with diesel-electric power. New pumps were installed, giving it a capacity of 22,800 gallons of water per minute. Sporting a new look, it returned to service in March 1950 redesignated as Engine No. 4. The *Alki* was redesignated Engine No. 3 at the same time. (Courtesy author.)

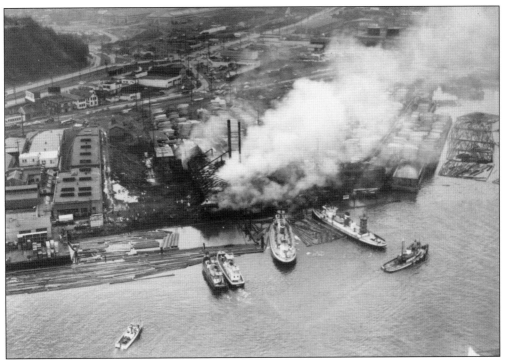

Here the *Alki* and the *Duwamish* team up to fight a stubborn fire at the West Waterway Lumber Company on January 27, 1952. (Courtesy of MOHAI, PI 22973.)

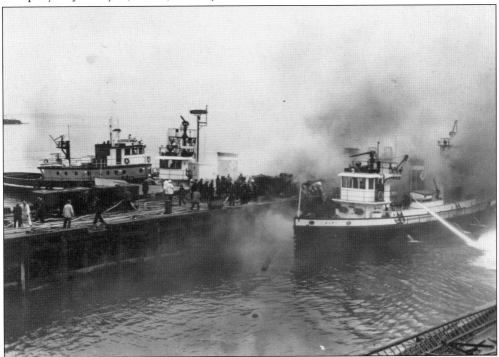

Both fireboats are pictured again at the smoky Todd Shipyard fire on Thanksgiving Day, November 28, 1968. (Photograph by Frank Skidmore; courtesy of Local 27.)

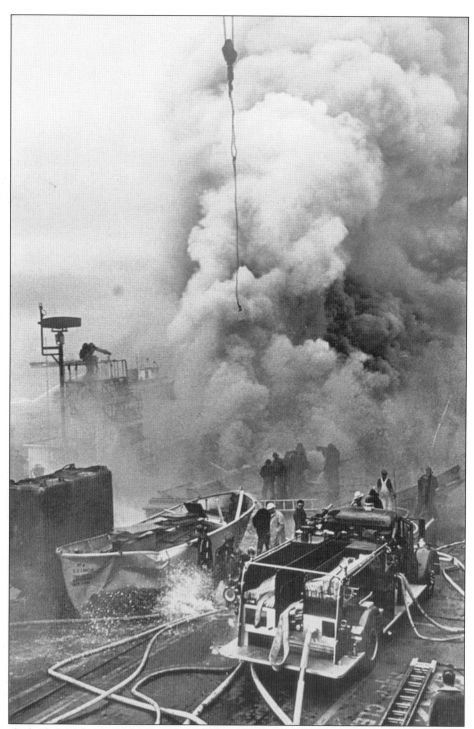

Smoke boils from beneath the dock at Todd Shipyard's Thanksgiving Day fire. Firefighter Henry Gronnerud was electrocuted at this fire while helping string up temporary electric cables for emergency lights and died shortly after midnight. The fire at the northwest end of Harbor Island burned from just after 1:00 p.m. to 3:00 a.m. (Courtesy of Local 27.)

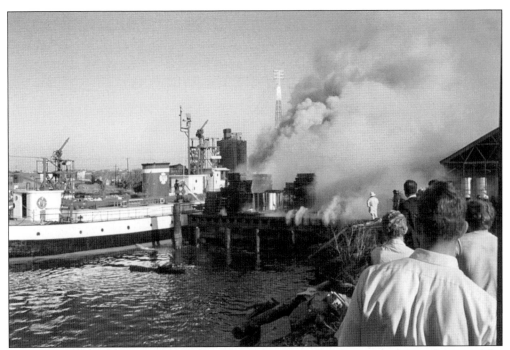

Fire chief Gordon Vickery directed operations when fire burned an open pier at the site of the old West Waterway Lumber Company late in the afternoon on October 4, 1969. The fireboat *Duwamish* assisted in the operations. (Courtesy author.)

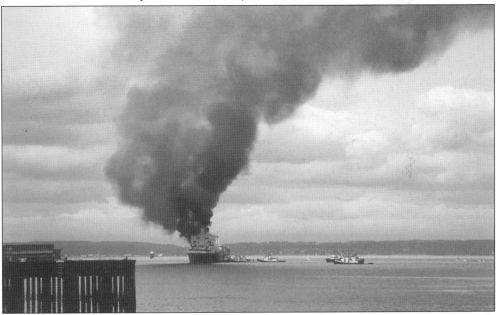

Land-based fire apparatus was not an option when fire struck the oil tanker SS *Cygnus* shortly after 11:00 a.m. on July 1, 1973. The ship was at anchor in Elliott Bay and was in the process of having its tanks cleaned of flammable residue before entering a shipyard when an explosion ignited it. Firefighters were ferried in rotation by the Seattle Police Harbor Patrol all afternoon and into the evening. (Courtesy author.)

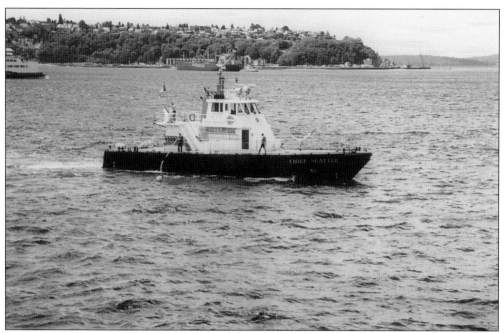

On January 8, 1985, the *Chief Seattle*, a state-of-the-art fireboat built by Nichols Brothers of Whidbey Island, was placed in service as Engine No. 4, retiring the *Duwamish*. The boat is capable of pumping 7,500 gallons of water per minute. (Courtesy author.)

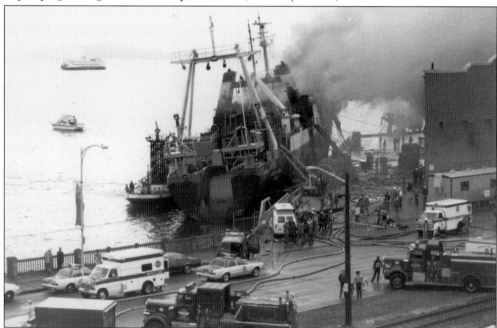

The fish-processing vessel M. V. *Golden Alaska* was hit by a major fire about 11:30 p.m. on May 9, 1989. The fire was not controlled until 4:30 the next afternoon, only after 18 firefighters suffered burns, heat exhaustion, and other injuries. The fire was caused by sparks from a welding torch during repair work on the deck. Hot work on vessels has been a major cause of Seattle's ship fires over the years. (Courtesy of Local 27.)

Nine

INTO THE 21ST CENTURY

The census at the beginning of this millennium puts Seattle's population at 563,374. This period also witnessed a rapid turnover of fire chiefs in the city. Chief Sewell resigned to study for the ministry on January 16, 2001. Fire marshal Gregory Dean temporarily filled in until July of that year when Gary Morris, the fire marshal from the Phoenix Fire Department, was appointed as permanent chief. Chief Morris resigned on January 13, 2004. Fire marshal Dean again filled in before being made the permanent chief on April 16.

After the September 11, 2001, attack on the World Trade Center, the Puget Sound Urban Search and Rescue Task Force spent several weeks in New York City. This group, formed after the attack on Oklahoma City's Federal Building, is made up of officers and firefighters from Seattle and other jurisdictions in western Washington. Chief Morris briefed the crews before their takeoff.

Replacement of apparatus has been steady since the beginning of the 21st century. Eight new pumpers were delivered in 2003, six pumpers and two ladder trucks are on order in 2006 along with a new rescue truck and a new hazardous-materials truck, and one large and one small fireboat are also under construction. Specialized apparatus have also arrived to provide assistance in the event of an emergency in one of Sound Transit's light-rail tunnels and subways now under construction in the city. Other equipment has been purchased with Homeland Security funds. In 2005, every member received new safety equipment, including new turnout gear. Now the men and women of the Seattle Fire Department are ready for the 21st century.

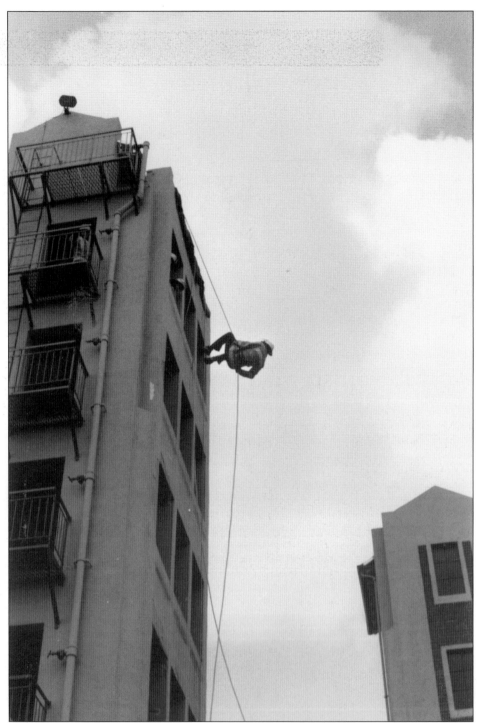

The seven-story drill tower built in 1927 with Fire Station No. 14 still serves the fire department for ladder and lifeline training. It was just replaced as the primary training center in April 2006. The new state-of-the-art facility on Myers Way is now home to the Training Division. (Courtesy of Local 27.)

During the 1990s, the firefighters of Station No. 14 received specialty training in various rescue techniques. Specific subjects included confined space, high angle, structural collapse, and water rescue as well as extrication. Here an injured worker is removed from atop a ship as part of a high-angle rescue. (Courtesy of Local 27.)

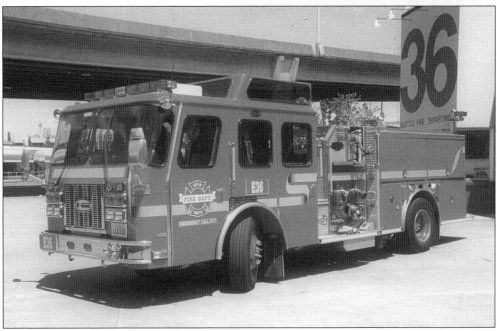

Engine No. 36 is using one of 10 Protector model pumpers built by Emergency One in 1995 and 1996. They feature a 1,500-gallon-per-minute pump with a control panel mounted on top behind the four-door cab. (Courtesy author.)

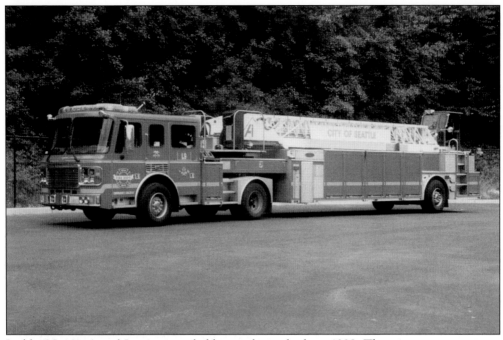

Ladder No. 9's Aerial Innovations ladder truck was built in 1998. The tractor portion is an American LaFrance Eagle model. (Courtesy author.)

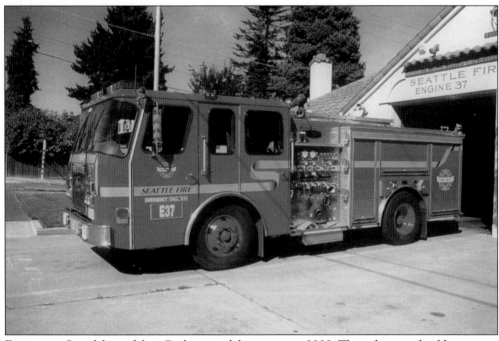

Emergency One delivered four Cyclone model pumpers in 2000. Their shorter wheel bases were designed for residential areas with winding, narrow streets. (Courtesy author.)

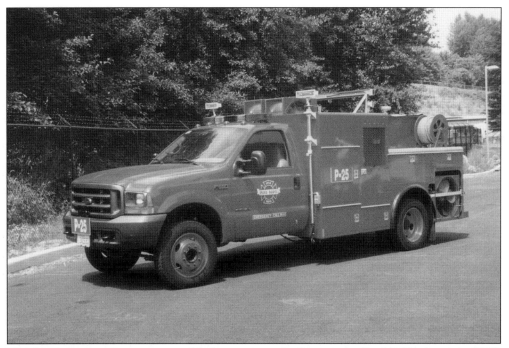

The fire department's generator and light unit was rebuilt on a new Ford F-550 chassis in 2000. The truck carries a cascade system of 18 fifty-pound carbon-dioxide cylinders for fires involving electrical vaults. (Courtesy author.)

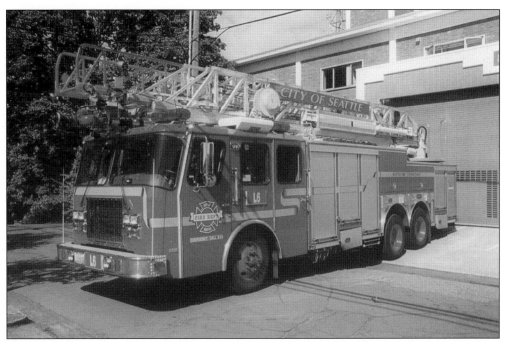

Two 2000 Emergency One Cyclone model 100-foot aerial-ladder trucks feature a pre-plumbed waterway for the ladder pipe. This truck is at Ladder No. 6 on Queen Anne Hill. (Courtesy author.)

During its demolition on April 18, 2002, the Princeton Avenue Bridge over the Burke-Gilman Trail collapsed under the weight of a heavy tracked backhoe, and extrication of the trapped operator took two hours. The severely injured operator survived, as paramedics provided treatment the whole time. (Courtesy of Seattle City Archives, 129490.)

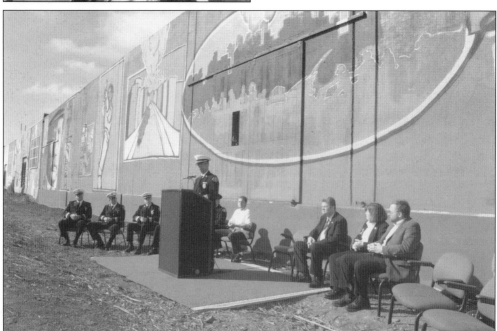

Fire chief Gary Morris speaks at the dedication of a firefighters' mural on September 11, 2002, as Mayor Greg Nickels, in suit and tie at left, listens. The mural is part of a larger group of murals on Fifth Avenue South near Fire Station No. 14. (Courtesy of Seattle City Archives, 131728.)

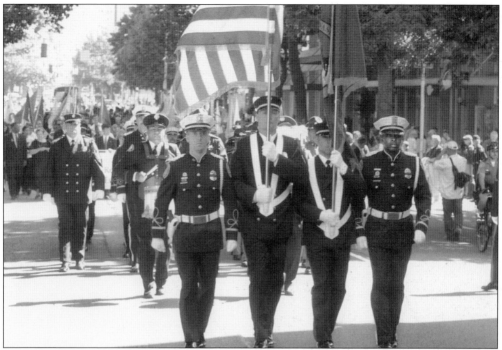

The Seattle Fire and Police Honor Guards teamed up during a memorial parade from Westlake Park to the Seattle Center on September 11, 2002. (Courtesy of Seattle City Archives, 131843.)

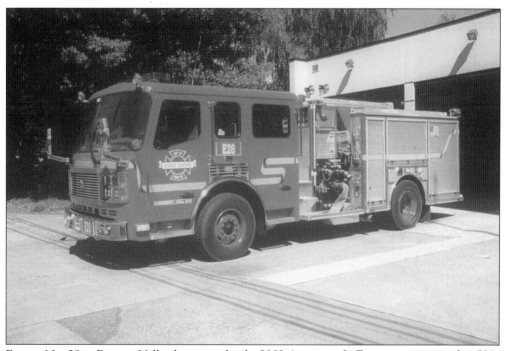

Engine No. 28 in Rainier Valley has one of eight 2003 American LaFrance pumpers with 1,500-gallon-per-minute pumps. Like many of Seattle's pumpers, these feature a top-mounted pump control. (Courtesy author.)

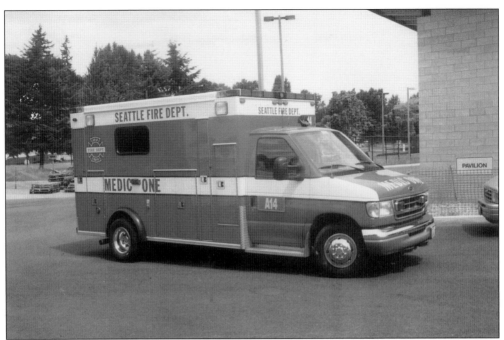

Aid Car No. 14's 2003 Ford van is equipped with a body by Braun Northwest, Inc., typical of all aid cars and medic units in the city. (Courtesy author.)

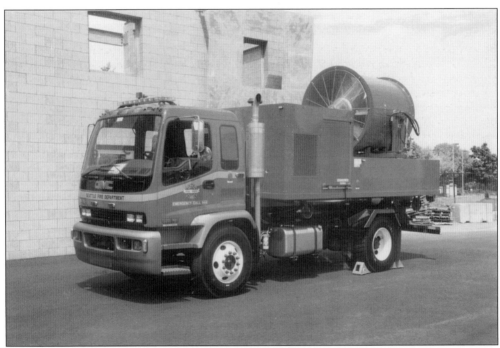

To remove smoke from its subways and tunnels, Sound Transit purchased for the fire department this large-diameter mobile-ventilation fan. It was built by Tempest Technology and is powered by its own 130-horsepower Cummins diesel engine. The unit is mounted on a 2005 GMC chassis. (Courtesy author.)

Ten

THE CHIEFS

Presented here are the 20 chiefs of the Seattle Fire Department since its reorganization in October 1889. There were times when no permanent chief was available, such as when a chief retired and his successor had not yet been chosen. During those times, interim chiefs were installed to run the department, being returned to their prior rank afterward. As has been noted, assistant chief William H. "Skipper" Clark ably ran the show on several such occasions. Those were September 24, 1894, to February 18, 1895; June 2 to July 20, 1895; and April 24 to June 9, 1911.

It is fitting here to mention the others who have so served. They are: William P. James, July 6 to October 14, 1963; James Q. King, January 20 to February 7, 1975; Theodore E. Gideon, December 28, 1984, to July 1, 1985; Donald R. Taylor, January 1 to March 26, 1997; and Gregory M. Dean, January 16 to July 23, 2001. Their contributions over the years are very much appreciated.

All the photographs in this chapter are courtesy of the Seattle Fire Department except where noted otherwise.

Gardner Kellogg (October 22, 1889, to November 1, 1892, and June 9, 1896, to February 21, 1901) was Seattle's first paid fire chief as well as the first chief of the volunteers. He rightly may be called the "Father of the Seattle Fire Department."

Albert B. Hunt
November 1, 1892, to September 24, 1894

Alex Allen Jr.
February 18, 1895, to June 2, 1895

Ralph Cook
July 20, 1895, to June 9, 1896,
February 21, 1901, to December 29, 1906

Harry W. Bringhurst
December 29, 1906, to March 21, 1910

John H. Boyle
March 21, 1910, to April 24, 1911

Frank L. Stetson
June 9, 1911, to October 2, 1920

George M. Mantor
October 2, 1920, to February 10, 1931

Robert L. Laing
February 10, 1931, to June 6, 1932

Claude W. Corning
June 6, 1932, to April 26, 1938

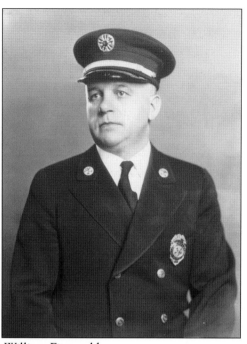

William Fitzgerald
April 26, 1938, to July 6, 1963

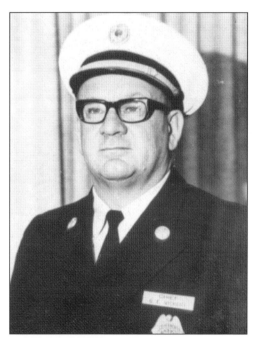

Gordon F. Vickery
October 14, 1963, to July 3, 1972

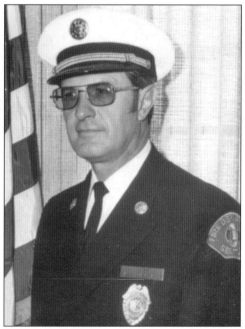

Jack N. Richards
July 3, 1972, to December 24, 1974

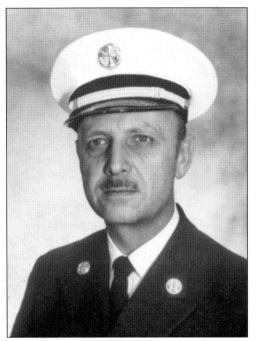

Glenn A. Shelton
December 24, 1974, to January 20, 1975

Frank R. Hanson
February 7, 1975, to December 31, 1979

Robert L. Swartout
January 1, 1980, to December 28, 1984

Claude Harris
July 1, 1985, to December 31, 1996
(Courtesy Chief Harris collection.)

James E. Sewell
May 27, 1997, to January 16, 2001

Gary P. Morris
July 23, 2001, to January 13, 2004

Gregory M. Dean
January 13, 2004, to present

In Memoriam

This is a list of those Seattle Fire personnel who fell in service to the community.

1. Herman Larson	March 9, 1891
2. Charles E. Brabon, Engineer	March 6, 1899
3. Victor D. Manhart	September 26, 1905
4. Jacob N. Longfellow, Captain	December 15, 1910
5. Patrick Cooper	August 2, 1914
6. Fred G. Gilham, Battalion Chief	January 20, 1917
7. Ole G. Rust	July 24, 1917
8. Peter Coghlan	November 20, 1919
9. Charles F. Lacasse	April 7, 1920
10. Leo P. Hertel	December 24, 1922
11. Horace E. Roberts, Captain	June 23, 1923
12. William E. Shuberg	September 22, 1924
13. Cecil McKenzie	August 7, 1925
14. Darwin T. Lund	June 30, 1927
15. Charles E. Wheeler	May 3, 1928
16. Albert S. Wolpert, Captain	October 1, 1937
17. Theodore R. Cousland	June 2, 1938
18. Luther D. Bonner	February 20, 1943
19. Andrew G. Beattie, Captain	December 11, 1945
20. Fred O. Larsen	March 22, 1947
21. Jack W. McGee	May 7, 1949
22. Glen S. Murphy	September 11, 1949
23. James Willey	January 10, 1957
24. John F. Herron	July 23, 1964
25. Harold W. Webb, Captain	October 14, 1966
26. Henry C. Gronnerud	November 29, 1968
27. Gerald Miller	May 10, 1976
28. Mary R. Matthews	January 14, 1984
29. Robert D. Earhart	July 12, 1987
30. Matthew W. Johnson, Lieutenant	September 9, 1989
31. James T. Brown	January 5, 1995
32. Walter D. Kilgore, Lieutenant	January 5, 1995
33. Gregory M. Shoemaker, Lieutenant	January 5, 1995
34. Randall R. Terlicker	January 5, 1995

ACROSS AMERICA, PEOPLE ARE DISCOVERING SOMETHING WONDERFUL. *THEIR HERITAGE.*

Arcadia Publishing is the leading local history publisher in the United States. With more than 3,000 titles in print and hundreds of new titles released every year, Arcadia has extensive specialized experience chronicling the history of communities and celebrating America's hidden stories, bringing to life the people, places, and events from the past. To discover the history of other communities across the nation, please visit:

www.arcadiapublishing.com

Customized search tools allow you to find regional history books about the town where you grew up, the cities where your friends and family live, the town where your parents met, or even that retirement spot you've been dreaming about.